The Elgin Marbles

B F Cook

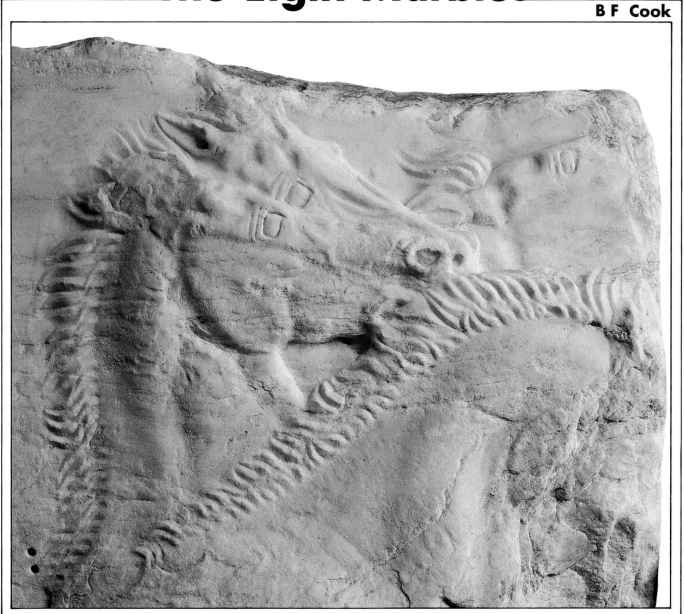

HARVARD UNIVERSITY PRESS

Cambridge, Massachusetts

1984

Copyright © 1984 by the Trustees of the British Museum
ISBN 0-674-24626-8
Library of Congress Catalog Card Number 83-049089

Designed and produced by Roger Davies
Set in Zapf Book Light
Printed in Italy by New Interlitho

The Parthenon from the east in 1765. Unfinished watercolour by William
Pars. British Museum Department of Greek and Roman Antiquities.

THE TRUSTEES OF THE BRITISH MUSEUM
acknowledge with gratitude the generosity
THE HENRY MOORE FOUNDATION
for the grant which made possible
the publication of this book

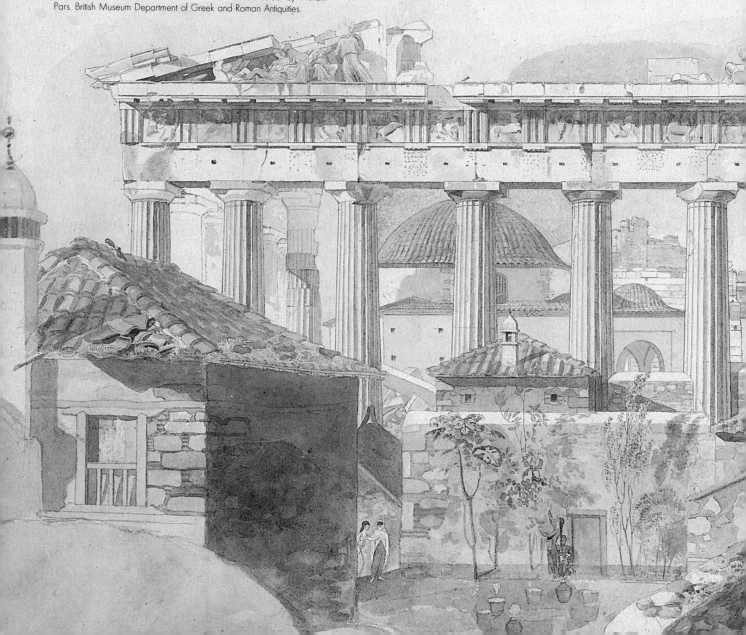

Contents

Preface

This book is a descendant of *A Short Guide to the Sculptures of the Parthenon in the British Museum (Elgin Collection)*, first published in 1921, by Arthur Hamilton Smith, Keeper of Greek and Roman Antiquities from 1909 to 1925. A revised version by Bernard Ashmole, Keeper from 1939 to 1956, was first printed in 1949 to coincide with the reopening of the Elgin Rooms after the Second World War. On the opening of the Duveen Gallery in 1962, a new version including an extended account of the history of the sculptures by D.E.L. Haynes, Keeper from 1956 to 1976, was published as *An Historical Guide to the Sculptures of the Parthenon*.

When Smith wrote his *Short Guide* his more detailed work, *The Sculptures of the Parthenon*, published in two folio volumes in 1910, was the most complete and most fully illustrated scholarly account of the subject. Since then many scholars have contributed to our knowledge of the Parthenon and of Lord Elgin, and the present author gladly acknowledges his debt to them, especially to Bernard Ashmole, John Boardman, Frank Brommer, Martin Robertson and William St Clair, as well as to the earlier *Guides*.

Many colleagues have helped with the production of this book, in particular Sue Bird, Sheila Hayward and Marian Vian of the Department of Greek and Roman Antiquities and A.W. Cowell of the Photographic Service. The book also owes more than the reader will perhaps guess to the patience and understanding of the author's wife, and it is, therefore, dedicated:

TO VERONICA.

Brian Cook
July 1983

Introduction

In 1816 the Earl of Elgin petitioned the House of Commons to purchase the large collection of marbles – sculptures, architectural fragments and inscriptions – that he had assembled while serving as British Ambassador to the Ottoman Court. The Elgin Marbles, as they have come to be known, were placed in the British Museum and have remained ever since one of its chief attractions to artists, scholars and millions of ordinary visitors. For part of the nineteenth century they were exhibited as a single collection in galleries built specially for them. More recently, many of the marbles in the collection have been dispersed to find their proper context in other parts of the Museum's exhibition of Greek antiquities. The essential nucleus, however, has always consisted of the sculptures removed from the Parthenon at Athens, which have been exhibited since 1962 in a gallery built at the expense of the late Lord Duveen.

These splendid sculptures are important not only for their aesthetic qualities, which are best judged by the eye of the individual observer, but also for their central place in the cultural history of ancient Athens. We must, therefore, begin in Athens and look in some detail at the city that built the Parthenon: how it was governed, and how the money required to finance this huge project was raised and spent.

1 Earthenware jar (amphora) for the olive oil awarded as a prize in the Panathenaic Games. This is one of the earliest surviving examples of a Panathenaic prize amphora, made in Athens about 566 BC. Beside the figure of Athena is the inscription 'I am [one] of the prizes from Athens'. *British Museum Catalogue of Vases* B 130.

1 Athena and Athens

The Parthenon was built between 447 and 438 BC on the Acropolis (i.e. the upper city or citadel) at Athens. It was dedicated to Athena, the daughter of Zeus, a warrior-goddess who sprang from her father's head already fully armed with helmet, shield and spear. She was a powerful protector of palace and citadel, but was also a patron of craftsmanship. Her cult was ancient and widespread. Her main festival at Athens, the Panathenaia, was celebrated on her birthday, the twenty-eighth day of Hecatombaion (a month that overlapped July and August). The Panathenaia was a very ancient festival, the oldest features of which seem to have been a procession and a sacrifice. Around the middle of the sixth century, perhaps in 566 BC, equestrian and athletic competitions were added every fourth year, when the festival was known as the Great Panathenaia. The prizes consisted of olive oil from Athena's sacred olive trees presented in large jars of a special shape, with a representation of the relevant sport on one side and of Athena herself on the other. The exact programme of the competition is not known, but Aristotle records that in the fourth century the festival was administered by ten *Athlothetae*, who organised the contests, supervised the collection and distribution of the olive oil and arranged for the making of the peplos. This was a woollen robe, specially woven for the occasion and decorated with a representation of the battle of the gods and giants, in which Athena took part. At the Great Panathenaia it was taken in procession to the Acropolis to be presented to the goddess.

By the fifth century BC the entire Acropolis was a holy place, dedicated to the cult of

Athena and the other divine patrons of Athens. Its only mortal residents were the privileged few who served the gods, the priestess of Athena and the *Arrephoroi*, a group of girls whose duties included a rather obscure ritual carried out by night and the setting up of the loom for the peplos. In legendary times, however, the Acropolis was the seat of government, crowned by the palace of the kings of Athens. The memory of what must have been a palace of the Mycenaean period survived until the time of Homer, who describes in the *Odyssey* how Athena came to Athens and entered 'the strong house of Erechtheus'. Rebuilding on the Acropolis over many centuries has removed even the foundations of this Mycenaean palace, although traces do remain of the Mycenaean fortifications.

When the actual history of Athens begins to become clear in the eighth and seventh centuries BC, the city already controlled all the surrounding land (Attica) and was itself ruled not by a king but by an oligarchy, a group of landed families who not only held most of the wealth of the city but monopolised the state and religious offices. Government was shared between a council of elders (Areopagus) and elected officials who severally exercised the political, military and religious functions of the king: the Archon ('ruler'), Polemarch ('war-ruler' or commander-in-chief) and the Archon Basileus ('king archon'), who was responsible for the state religion. Together with six Thesmothetae ('lawgivers'), whose precise function is obscure, these were known as the Nine Archons.

In most Greek cities this kind of oligarchic constitution led to a political and economic crisis in which power was seized by a *tyrannos*, not a 'tyrant' in the modern sense of a cruel despot, but simply an unconstitutional ruler. In Athens this was delayed by Solon's establishment of a limited democracy shortly before 590 BC. None the less in 561/60 Pisistratus seized power as tyrant, and with some interruptions tyranny at Athens lasted until 510 when his son Hippias was expelled.

After the expulsion of Hippias the constitutional reforms of Cleisthenes introduced a more advanced form of democracy. For political and military purposes the citizen body was divided into ten tribes, each named after a legendary hero. Fifty citizens were selected annually from each tribe to form the council (Boule) of five hundred and to serve for a tenth of the year as a kind of standing committee, the *prytaneis* or presidents, who also took the chair at meetings of the assembly (*Ekklesia*). Each tribe also elected annually a general (*Strategos*). Although the Nine Archons were retained in the constitution of Cleisthenes, from 487/6 they were no longer elected but chosen by lot. Their importance therefore declined and that of the generals, who were still elected, became correspondingly greater.

Meanwhile the very existence of the new democracy was threatened by a foreign invasion. In 490 BC Darius, King of Persia, invaded Attica, landing at Marathon with a large force of infantry, cavalry and archers. Against this mighty army stood the Athenians, aided only by a small band of men from Plataea in Boeotia. Together they routed the invaders, slaughtering several thousand Persians for the loss of only 192 Athenians and a handful of Plataeans. The men who fought at Marathon (*Marathonomachoi*) were always highly honoured, and those who fell in the battle were revered as heroes.

Ten years later a second invasion, on a much larger scale, was launched by Xerxes,

2 The Acropolis at Athens from the south-west.

3 The Erechtheion on the Acropolis at Athens from the south-west. This temple, built towards the end of the fifth century BC, housed the ancient olive-wood cult-statue of Athena.

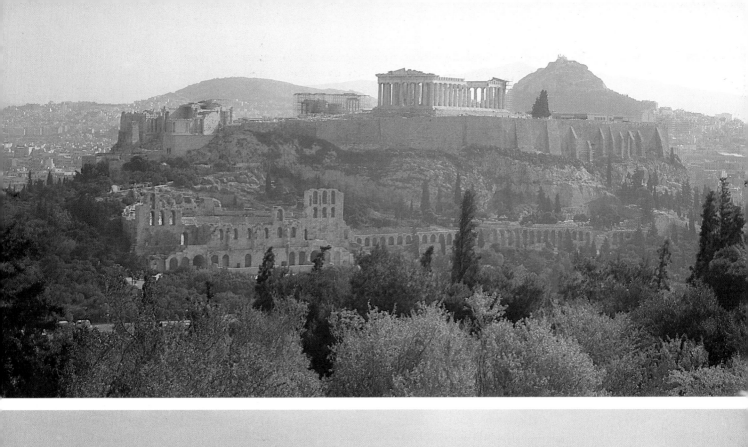

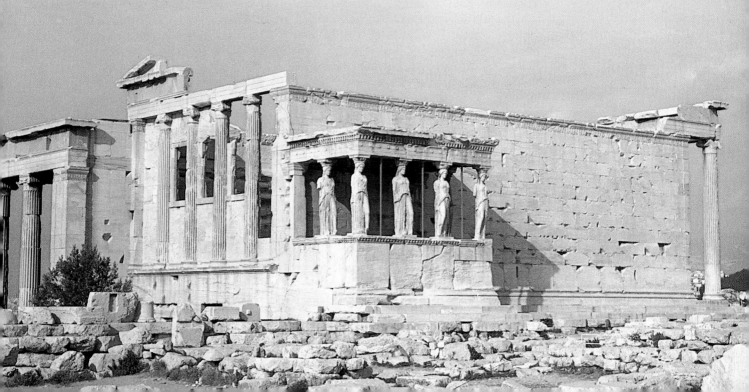

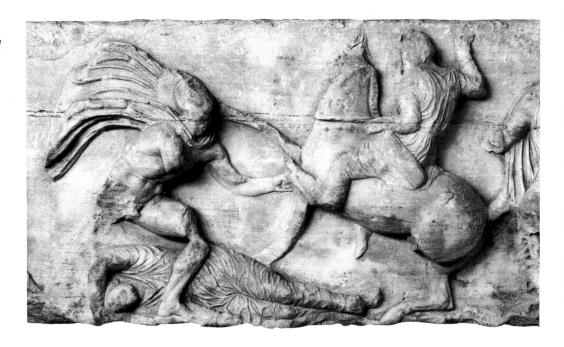

4 Part of the frieze of the temple of Athena Nike on the Acropolis at Athens, showing a fight between Greeks and Orientals, probably Persians. Carved about 425 BC. *British Museum Catalogue of Sculpture* 424 (Elgin Collection).

son of Darius. After a valiant rearguard action at Thermopylae, where three hundred Spartans perished, the whole of Greece north of the Isthmus of Corinth was abandoned to the Persians. The Athenians evacuated their city, taking with them their holiest possession, the ancient olive-wood statue of Athena. The Persians sacked both the town and the Acropolis, including an unfinished temple to Athena on a terraced site at the summit. The Greeks, however, stood firm. A combined fleet under Athenian command defeated the Persian navy at Salamis in 480, and in the following year the Persian army was beaten at Plataea by a Greek force led by the Spartans. According to tradition the Greeks then swore an oath not to rebuild the shrines desecrated by the Persians but to leave them as a memorial of barbarian impiety.

Although the Persians had been repulsed they were still seen to pose a threat to Greek freedom. A maritime alliance was, therefore, established by the Athenians and a large number of independent Greek cities. The Athenians provided the largest contingent in the allied fleet, while the allies made their contributions in ships or money. How much each city should contribute was assessed by the Athenians, and the treasurers of the League (*Hellenotamiae*) were Athenian citizens. The funds themselves were kept in the sanctuary of Apollo on the island of Delos, and, since the assembly of the allies also met there, the alliance came to be known as the Delian League.

Soon the allies, nominally all free and equal, began to find that it was easier to join the Delian League than to resign. First Naxos and then Thasos attempted to secede, only to be besieged by the Athenian fleet. When Thasos capitulated in 463 she had to dismantle her city-walls, surrender her fleet and start to pay tribute. Other cities

found it more convenient to contribute money instead of ships, and by 450 only Chios, Lesbos and Samos retained their fleets, leaving Athens unrivalled at sea. Her fleet protected the Aegean from pirates as well as Persians, but it also enforced payment of the tribute. The Delian League had begun to evolve from a free alliance to an Athenian empire.

At about the same time the Athenian democracy became yet more radical following reforms introduced by Ephialtes in 462/1. The power of the Areopagus was finally broken and the will of the people became paramount. At the end of their year of office magistrates and other officials were examined on their conduct, especially in financial matters. Decrees of the assembly and financial accounts were published by

inscribing them on stone slabs, which survive, at least in fragments, in increasing numbers from this period.

Soon after this Ephialtes was assassinated and Pericles became the leader of the Athenian democracy. He made his reputation as a successful general by 450, and he maintained his political influence by constant re-election to the office of *Strategos* and by his commanding rhetoric in the assembly. The Athenians were already prepared in the 460s to use force to prevent allies from leaving the league. By the 450s they were interfering in the internal politics of allied cities, installing garrisons and resident Athenian officials to supervise the collection of tribute. In 454 BC, following a military disaster in Egypt, the treasury of the League was moved from Delos to the greater safety of the Athenian Acropolis.

In 449/8 hostilities ceased, probably on terms negotiated by Callias, and the Persians henceforth ceased to menace the Greek cities. This was the crucial moment for the Delian League. Athens now had the choice of allowing the League to lapse, its aims having been achieved, or maintaining it in existence under her direct and explicit rule.

She seems not to have hesitated, and by the early 440s the transformation from Delian League to Athenian Empire was virtually complete. The new status of the allies can be seen in decrees passed by the Athenian assembly: the allies are now frankly called 'the cities which Athens controls', and the tribute continued to be levied although its ostensible purpose, victory against the Persians, had been accomplished. A decree proposed by Clinias, inscribed on a stone slab of which fragments survive in Athens and London, provided measures to ensure the payment of tribute each year, with prompt reminders for those

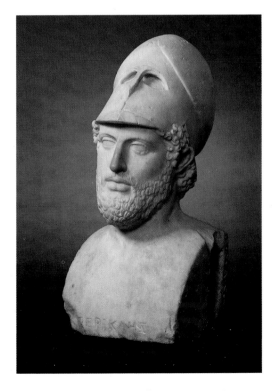

5 Portrait of Pericles wearing a helmet. Copied in marble in the Roman period from an earlier Greek original. The name is inscribed in Greek. *British Museum Catalogue of Sculpture* 549 (Townley Collection).

6 Athenian silver tetradrachms (four-drachma coins) minted about 450-406 BC. Obverse: head of Athena, helmeted; reverse: owl, olive-branch and inscriptions, Athe[ns]. Coins like these were in circulation throughout the Athenian Empire while the Parthenon was being built. British Museum *BMC Athens* 42 and 46.

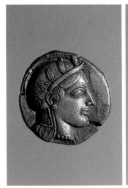
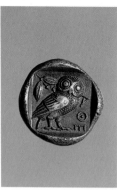

7 Fragment of a marble slab recording the decree proposed by Clinias concerning the tribute collected by Athens from her subject allies. *Greek Inscriptions in the British Museum* VI (Elgin Collection). Other fragments of the decree are in the Epigraphic Museum in Athens.

who failed to pay on time. Reference is made to the allied cities' additional responsibility to provide annually a set of armour and a cow for sacrifice at the Panathenaia. Another decree made the use of Athenian silver coins compulsory throughout the Empire: loss of the right to mint their own coins shows clearly that the allied cities were no longer free. The transfer of the League's treasury from Delos in 454 left the Athenians in control of vast funds originally raised as the allies' war-chest. They now lost no time in passing a further decree authorising the expenditure of the accumulated reserve, amounting to some 5,000 talents, on a massive building programme.

The proposal was not without its critics. If Plutarch's account can be trusted – it was written some five hundred years later but drew on many sources now lost to us – the decree was opposed by those who thought it was shameful to spend the allies' war-chest on bedecking Athens with temples. Pericles replied that, since it was the Athenians who kept the Persians at bay, they were entitled to spend the surplus as they thought fit. By further pointing out that his programme of public works would bring employment to large numbers of craftsmen in the city, Pericles carried the day. A whole series of temples and other buildings were erected in and around Athens. 'The most remarkable thing', Plutarch comments, 'was the speed' [with which they were built]. The most remarkable of the buildings was the Parthenon.

8 *right* Part of the Parthenon frieze showing a cow led for sacrifice. Sacrificial animals for the Panathenaia were provided by the cities under Athenian rule. Much of the meat was distributed free to Athenian citizens. South frieze, Slab XL.

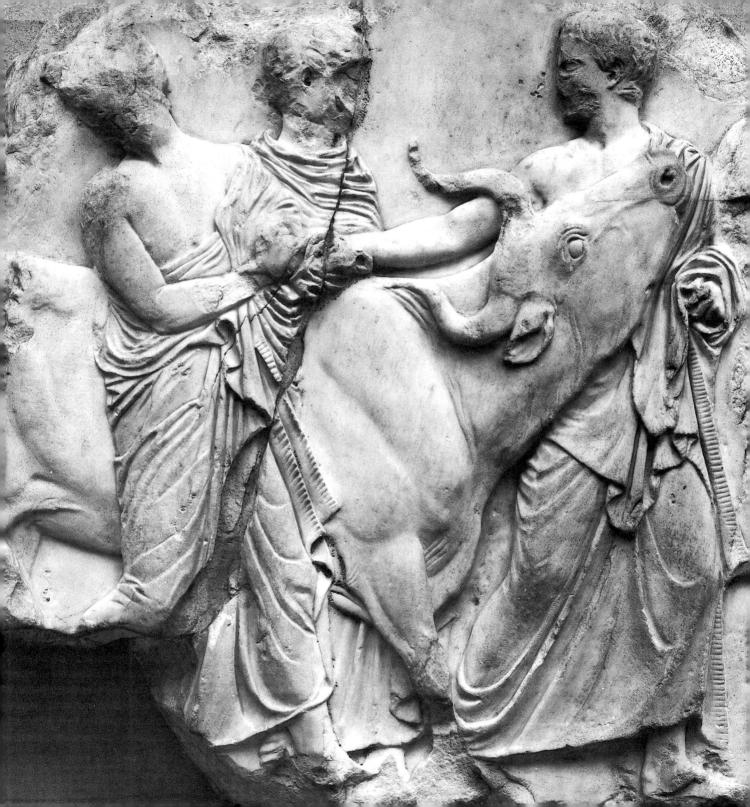

2 The Parthenon

The Building of the Parthenon

At the Panathenaic festival in 438 BC the Athenians dedicated the new statue of Athena by Pheidias. It was about 12m high and was made of gold and ivory over a timber frame: ivory for the flesh, gold for the drapery and accoutrements. By this time the temple in which it stood must have been substantially complete, although work was to go on for several years on its sculptures.

The kernel of the Parthenon was an oblong building with a porch of six columns at each end leading into two rooms of unequal size, which were not interconnected. The statue stood in the larger room, at the east end. The smaller room to the west seems to have been used only as a treasury, but its original name, 'The Parthenon' (later applied to the whole structure), means 'room of the maidens' and suggests that it had been intended to house those who served the goddess. Around the outside of this central building ran a peristyle, or colonnade, of forty-six columns (eight across each end and seven-

teen along the flanks, counting the angle-columns twice). The whole temple stands on a base with three steps, and there are two more steps up into the porches.

The order is basically Doric. The columns, which have no bases but stand directly on the top step, have broad, shallow flutes and a plain capital. They support a marble beam (the epistyle or architrave) on which rests a Doric frieze consisting of sculptured panels, or metopes, each about 1.25m square, alternating with vertically grooved blocks known as triglyphs. Crowning the frieze is an overhanging cornice, which ran all around the building, serving at the ends as the base for a low triangle, the pediment, in the gable of the pitched roof. Both pediments were filled with groups of marble sculptures. The roof was originally covered with tiles, made of marble like the coffered ceiling of the colonnade. The internal ceilings and the substructure of the roof were of timber.

Into this Doric building the architect introduced a number of features from the Ionic order. The most prominent was the replacement of the Doric frieze of triglyphs and metopes over the inner porches by an Ionic frieze sculptured in low relief without interrupting triglyphs. The frieze was extended along the sides of the building, so that it formed a continuous sculptured band around the central structure below the ceiling of the colonnade.

There were thus three types of figured sculpture on the temple: the metopes, carved in high relief; the continuous frieze in low relief; and the pediments, consisting of groups of figures carved in the round. In addition, the apex and corners of each pediment were crowned with finials or acroteria. These were composed of floral motifs including palmettes, but they survive only in fragments and their restoration is conjectural. The drawing (fig. 9) shows

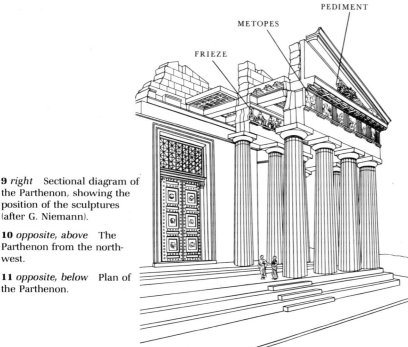

PEDIMENT

METOPES

FRIEZE

9 *right* Sectional diagram of the Parthenon, showing the position of the sculptures (after G. Niemann).

10 *opposite, above* The Parthenon from the north-west.

11 *opposite, below* Plan of the Parthenon.

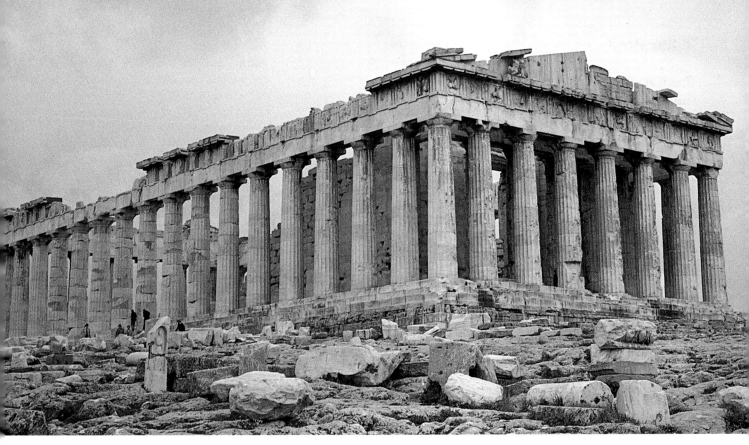

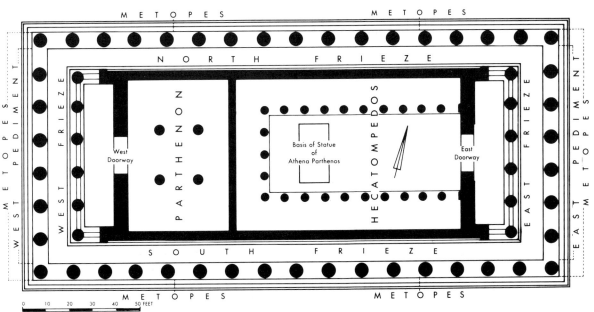

where the metopes, frieze and pediments were placed on the building.

All the sculptures were made of Pentelic marble, but some details of harness and weapons were added in metal, and other details as well as the backgrounds were painted in. None the less much of the fine detail now visible on the sculptures that are exhibited in museums must have been imperceptible owing to the height above the ground at which the sculptures were set. The frieze must have been particularly difficult to appreciate, being lit only by reflected light from below and being visible only in sections between the columns or at a very steep angle from inside the colonnade.

The architectural sculpture was not so much intended to delight the viewer as to contribute to the impressive overall effect of this extraordinary building, constructed entirely of marble to the highest standards of design and execution, and decorated with an unprecedented quantity of sculpture. The most important piece of sculpture was not on but in the building: the statue of Athena herself. There are even grounds for suggesting that the design of the temple was modified to accommodate the statue.

The Parthenon was built at the very summit of the Acropolis, supported partly by the rock itself and partly by a terraced platform originally erected more than thirty years earlier for a temple that had been under construction when the Persians sacked Athens in 480 BC. Some of its unfinished column-drums were built into the hastily re-erected northern defensive wall of the Acropolis, where they are still to be seen, but much of the rest of the old building must still have been lying in ruins on the site when, following the Peace of Callias, it became possible at last to think of restoring the ravaged Acropolis.

As usual under the Athenian democratic system, expenditure on the work was controlled by a commission of citizens, whose annual accounts were inscribed on stone slabs. Fragments of these slabs still survive, and provide much information to supplement the ancient literary sources. As Plutarch tells us, Pheidias was in overall charge of Pericles' building programme, but the Parthenon was built by Ictinus and Callicrates. Ictinus is also known as the architect of the Temple of Apollo at Bassae; Callicrates, who about this time was also involved in building the long walls between Athens and the port of Piraeus, was perhaps the master-builder who contracted the actual work.

Payments for quarrying and transporting the marble began in 447/6, but some time must already have been spent on planning the building and its sculptures, arranging for an army of sculptors, stonemasons, carpenters and other craftsmen of various kinds, and on clearing the site. It has been estimated that 22,000 tons of marble were eventually quarried on Mount Pentelicus and transported to the Acropolis. Blocks of the appropriate shape and size had to arrive as required, since the area of the Acropolis was very limited and space had to be allocated not only for the stonemasons and sculptors who carved the marble blocks, but also for a secure workshop in which Pheidias could produce the gold and ivory 12 statue.

Plutarch remarks that the most amazing feature of the Periclean building programme was the speed with which the actual buildings were completed. This is fully borne out by the Parthenon, begun in 447/6 and structurally complete by 438. The sculptures can also be dated fairly closely. A reference to the columns in the accounts for 442/1 implies that the colonnade was well advanced. The metopes would soon be

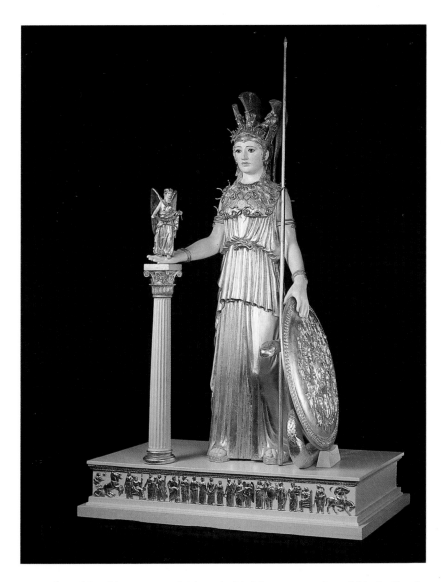

12 The gold and ivory statue of Athena by Pheidias: a restored model in the Royal Ontario Museum, Toronto.

required, for they had to be in place before the cornice-blocks could be laid and before construction of the roof, which was complete by 438. They are likely to have been carved between about 447/6 and 441/40. The slabs of the frieze, which were an integral part of the cella wall, are not mentioned in the surviving fragments of the accounts, but they must also have been in place some time before the roof was constructed. As we shall see, some were sculptured when already in place on the building, others probably on the ground beforehand. The pedimental figures were not yet ready at the dedication in 438, although work may have started on them. Payments for carving and erecting them did not end until 433/2.

What part did Pheidias play in all this? The old view that he oversaw every detail of the architectural sculpture, perhaps even carving some of the sculptures himself, is nowadays scarcely tenable. The physical labour of carving so many marble sculptures in such a short time required a large team of sculptors, and in the years before 438, when ninety-two metopes had to be completed and the frieze at least begun, Pheidias himself was inevitably much occupied with the design and construction of the great gold and ivory statue of Athena. Some of the decorative detail on the statue has the same subject-matter as some of the metopes, and this identical choice can hardly be coincidental. At the very least Pheidias must have been involved in deciding the themes of the metopes, and no doubt of the frieze and pediments too, but it is likely that much of the design work as well as the execution was shared by other sculptors.

On the other hand Pheidias must also have influenced the design of the temple itself. The larger of the two rooms in the cella building was the cella proper, where stood the great statue of Athena, its position

13 The Strangford Shield, a small marble copy made in Roman times of the shield of the Athena by Pheidias. *British Museum Catalogue of Sculpture* 302 (Strangford Collection).

housing not only the treasury of the Athenian Empire but also Pheidias' great statue, which according to Thucydides itself contained some 40 talents (say, 100 kg) of gold. It seems never to have played an important part in the cult of the goddess: her altar was in the open air a little farther north and her ancient olive-wood cult statue was eventually to find a home in the Erechtheion. The ultimate purpose of the Parthenon was to glorify Athena and her city: Athens, proud ruler of an empire that spread through the Aegean and beyond, making her one of the two great powers in the Greek world, rivalled only by Sparta in military strength, unrivalled in the wealth she drew annually from her tributaries.

Later History of the Parthenon

The Parthenon was finished in 432 BC, and it remained in use as a temple of Athena for almost a thousand years. Sometime around the fifth century, when the old pagan beliefs had yielded to Christianity, the building was converted into a church. An apse was built at the east end, necessitating the removal of part at least of the east frieze. It is possible that the central figures of the east pediment were removed at the same time and it is all but certain that this was the occasion for the deliberate defacement of most of the metopes on the east, north and west sides. At some stage windows were cut in the wall and a bell-tower was added at the west end.

Over a thousand years more were to elapse before the building and its sculptures suffered a second, and even greater, disaster. When the Turks conquered Athens in 1458 they turned the Parthenon into a mosque and added a minaret to the tower, but otherwise the structure remained in this almost complete state for another two centuries.

still marked by a rectangular cutting in the floor for the huge central beam of the armature. Its pedestal almost filled the space between the columns of the interior peristyle that was necessary to support the wide span of the ceiling. The Parthenon, in fact, although shorter than its predecessor had been planned to be, was distinctly wider. This change in proportion can only have been required in order to accommodate the statue: Ictinus adjusted the design of his temple to suit the requirements of Pheidias' statue.

The actual function of the Parthenon was indeed to serve as a double strong-room,

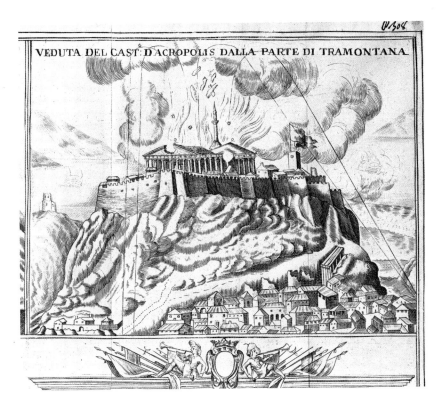

VEDUTA DEL CAST: D'ACROPOLIS DALLA PARTE DI TRAMONTANA

14 The explosion of 1687 (after F. Fanelli, *Atene Attiica*, 1707).

In 1674 the Marquis de Nointel, French Ambassador at the Turkish Court, visited Athens. In his party was an artist, who spent about two weeks drawing sculpture and architecture, particularly the sculptures of the Parthenon. He worked rapidly and under difficult conditions. He did not draw everything, but what he did draw seems to be reliable, for he did not invent details to make good the portions already missing. It is possible that he was Jacques Carrey of Troyes, although some critics dispute this attribution of the drawings. Whoever he was, his drawings, now preserved in the Bibliothèque Nationale in Paris, remain an invaluable record of the sculptures because the second disaster was at hand.

In 1687 the Turkish garrison on the Acropolis was besieged by an army under the Venetian General Francesco Morosini. At this time the Turks were using the Parthenon as a powder magazine, since the former magazine in the Propylaea had exploded when struck by lightning in 1645. On 26 September 1687 the Parthenon sustained a direct hit from a Venetian shell and the powder stored there exploded, 14 with disastrous effect. Most of the interior walls of the temple, apart from the west end, were destroyed, bringing the frieze down with them, and groups of columns were blown down on both the north and south sides, taking with them the entablature above and about half of the metopes on those sides. Further damage was inflicted by Morosini in an unsuccessful attempt to remove as booty the central figures of the west pediment, which had been almost intact a few years earlier.

When Morosini yielded the Acropolis to the Turks again, the Parthenon was a ruin. The Turks cleared the centre and built there a small mosque. What was still standing they left, but fallen sculptures and architectural members were at the mercy of stonerobbers and lime-burners. The eighteenth century brought an increasing number of Western visitors. Some of them, like William Pars, James Stuart and Nicholas Revett, came to draw; others took away fragments of sculpture as souvenirs, usually by bribing the local Turkish authorities.

3 The Sculptures of the Parthenon

The Metopes

All ninety-two metopes on the exterior of the Parthenon were originally decorated with sculpture in high relief. The slabs are 1.20m high and of varying width, averaging 1.25m. The blocks must have been about 35cm thick to begin with and now consist of slabs as little as 10cm thick behind the carved figures, which project in some places about 25cm. The slabs fit into grooves in the sides of the triglyph blocks and must have been in place before the cornice-blocks were laid above them. Since sculptures of this kind could hardly have been carved in place, over 13m above the ground under an overhanging cornice – especially when the roof was being constructed towards 438 – they must have been carved on the ground beginning no earlier than 447/6 and ending probably not much later than 442, certainly in time for the construction of the roof.

Most of the metopes had two figures but some had more. To carve so many figures in high relief in such a short time required a considerable number of sculptors. It is unlikely that enough were available in Athens: others must have been recruited up and down the Greek world. They will have been men of various ages and of different levels of competence, so that we may expect to find among the metopes works of older sculptors working in a conservative tradition side by side with those of younger men trained in more advanced styles. They were working to a strict deadline: there would be no time to discard unsuccessful compositions or damaged works. In any case, with sculptures at over 13m above the ground it was the overall effect that counted and most blemishes would be invisible.

Such a large number of carved metopes was without precedent on a Greek temple. Smaller buildings, such as the treasury of the Athenians at Delphi, might have their exterior metopes carved, but in the great Temple of Zeus at Olympia, built about 460 BC, the exterior metopes were left plain, and only those above the inner porch were sculptured. In the Hephaisteion at Athens, roughly contemporary with the Parthenon, sculptured metopes on the exterior were restricted to those on the east end and the four nearest them on each side. The decision to decorate all ninety-two metopes must have been deliberate, the intention being to enrich the building beyond all others and so to impress the visitor. It could not have been put into effect without the immense financial backing available from the tribute paid annually by the subject cities of the Athenian Empire.

The metopes on each side of the building had a different theme, and these subjects were evidently chosen with care. Those on the east – the most important side, because the main door of the temple opening on the statue of Athena was in the east – represent the battle between the Olympian gods and the giants who tried to expel and supersede them. Care was given to the design and planning of individual metopes so that they form a symmetrical overall composition with Zeus in one of the central pair and Athena herself in a prominent position. The metopes on the west end show Greeks fighting opponents in oriental dress, almost certainly Amazons, although the sculptures are in such a bad state that it is impossible to be sure that they are female. If the figures are actually male, the subject would be Greeks against Persians.

Many metopes in the middle of both north and south sides were destroyed in the explosion of 1687, but the earlier drawings attributed to J. Carrey form an invaluable supplement to those that survive. Some of the metopes on the north side show scenes from the Fall of Troy, including the meeting

of Menelaus and Helen as well as the escape of Aeneas and Anchises, and it is likely that the remaining metopes on this side were connected with the same theme. Unfortunately, like those on the east and west sides, they are not only heavily weathered but have also been systematically defaced. It has long been recognised that this must have happened when the temple was converted into a Christian church, for scaffolding would have been available then to make the iconoclasts' work easier. The last metope on the north side, however, survived because it shows a draped figure standing before a draped female seated on a rock and was evidently thought to be sufficiently like the Annunciation to be spared. The other, more obviously pagan subjects, succumbed to the desire of the early Church to break the links with the heathen past.

For some reason the metopes on the south side escaped defacement, perhaps because this side of the building is near the edge of the Acropolis so that the sculptures were less conspicuous. The metopes at either end of this series show individual combats between men and centaurs – monsters with human torsos growing out of horses' bodies. The subjects of the central metopes, known only from the Carrey drawings, remain obscure and scholars disagree about their interpretation. Some see the whole series as a single theme, an Athenian myth of a local struggle against the centaurs to which there is no reference in surviving literature. Others are willing to separate the centaur metopes from the rest and to see in them the fight that broke out when the centaurs, invited to the wedding of Peirithous, King of the Lapiths, in Thessaly, got drunk and tried to carry off the Lapith women. This is perhaps more likely, for one of Peirithous' guests was Theseus, King of

Athens, who is sometimes shown taking a prominent part in the struggle alongside his host (e.g. in the pediment of the Temple of Zeus at Olympia).

The subjects of the metopes recur often in Greek art during the fifth century, and three of them are found in the subsidiary decoration of Pheidias' statue of Athena: Greeks against Amazons on the outside of her shield, gods against giants on the inside, centaurs against Lapiths on the edges of the soles of her sandals. The recurrence must have been deliberate and suggests that Pheidias was involved at least in the choice of subjects for the metopes. All subjects appear to have a common theme: the conflict between order and chaos, between civilisation and barbarism. The Trojan War and the battle against the Amazons further suggest the conflict between East and West. All seem to refer allegorically to the Persian Wars in the early fifth century.

It was from the south side that fourteen metopes were removed for Lord Elgin since the others were on the whole not worth taking. The metopes from each side of the Parthenon are conventionally numbered from left to right using Roman numerals.

In metope III the Lapith attacks the centaur from behind, leaping on his back and seizing him by the throat. The centaur's forward movement is arrested but the sculptor has made rather heavy weather of the transition between the equine and human parts of his body. The Lapith's pose is stiff and the whole composition is rather static. His baldric and scabbard must have been added in bronze, since a dowel-hole for their attachment can be seen near the base of the rib-cage on his left side.

If metope III is stiff and somewhat old fashioned, metope IV is the work of a more powerful and forward-looking sculptor. The heads of the figures, which were

15

16

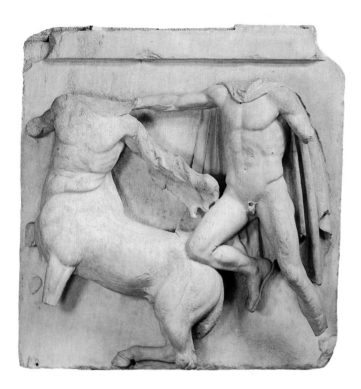

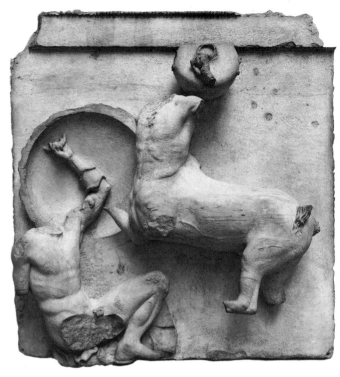

15 *above left* A centaur attacked by a Lapith. South metope III.

16 *above* A centaur about to strike a fallen Lapith with a water-pot (*hydria*). South metope IV.

removed in 1688 by a Dane serving under Morosini and are now in Copenhagen, are carved in an advanced classical style. They and some of the limbs were still in place in 1674 and Carrey's drawing helps to explain the action and composition. The Lapith has fallen backwards and is attempting to protect himself with a shield – he seems to be the only man with actual armour. The centaur is trampling him with his forelegs, forcing the shield aside, leaving the Lapith vulnerable to a blow from the water-pot that the centaur has raised and is about to dash down on him. It is a powerful composition, heavily weighted in the lower left corner, and the action, as in several other metopes, is frozen in the instant before the final, violent and decisive blow.

In metope VI an older centaur, slightly flabby and wrinkled, is grappling with a young Lapith, slim and lightly built, hardly more than a boy. The Carrey drawing showed the youth's right arm raised to ward off the centaur, but this arm and both legs have since disappeared, perhaps after the metope broke in its fall from the building in a storm.

Metope VII presents a more powerful and violent scene: the Lapith strides forward to meet the rearing centaur, gripping him with his left hand, ready to strike him in the very next moment with his right, which presumably held a sword. The heads are preserved: the youth's in Paris, the centaur's in Athens.

The upper part of metope VIII was destroyed in the explosion: what remains shows a vigorous composition although the treatment of the anatomy, especially of the youth's abdominal muscles, is rather linear

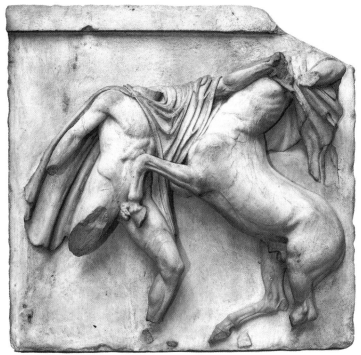

17 *above left* Drawing attributed to Jacques Carrey, showing the condition of south metope IV in 1674. Paris, Bibliothèque Nationale.

18 *above right* A Lapith grappling with a centaur. South metope VII.

19 *right* A Lapith forced to the ground by a centaur. South metope VIII.

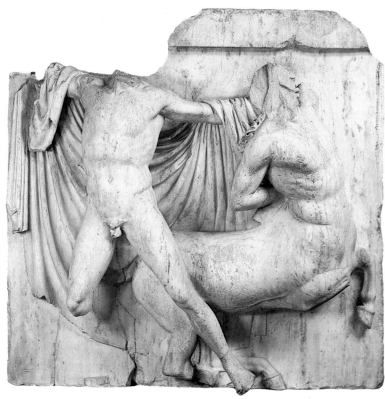

20 *above left* Detail of a centaur's head from south metope XXVI.

21 *above right* A Lapith tackles a fleeing centaur and prepares to strike a decisive blow. South metope XXVII.

and old fashioned. This is the work then of a skilled but conservative sculptor, perhaps an older man. The sculptor of metope XXVI was less competent. The composition is dull, the poses improbable, the centaur's face is old fashioned and impassive, his head set too low on his shoulders, as if he has no neck. Something went wrong with the carving too, for a large section of the Lapith's drapery is missing where an ancient patch has been lost.

By contrast metope XXVII is perhaps the finest of the series. The centaur attempts to escape, pressing his right hand to a wound he has already sustained in the back. The Lapith stops him, tackling him by the throat with his left hand, the strain evident in his outstretched left leg and the tension of his brilliantly modelled abdominal muscles. At the same time he draws back his right arm for another blow to finish the centaur off. The next moment will see the end, and meanwhile the action is frozen. The youth's cloak is frozen too, about to slip from his outstretched arms, but still forming a dramatic background to his body, which is carved in such high relief that it is almost detached from the background. The centaur's tail follows the line of a fold and must have been distinguished with paint. The composition is complex, with the antagonists concentrating on each other while straining physically in opposite directions, creating a balance that we shall see

again in the centre of the west pediment. In composition, anatomical knowledge and technical mastery this anonymous sculptor is unsurpassed among those who worked on the Parthenon.

The adjacent metope, no. XXVIII, is comparable in skill if not in style. Here the centaur is victorious, prancing in triumph over the limp body of his defeated foe. As a shield he uses the skin of a wild animal, a panther perhaps, and he has snatched up a large bowl to use as a weapon: much of it has broken away but a trace remains attached to the background over his right shoulder.

Metope XXIX shows not the fight but its cause: a centaur has seized a young girl and is carrying her off. The composition is unadventurous, the centaur's expression rather wooden, the girl's posture somewhat improbable, but her drapery is carved with

a wealth of crinkly detail that looks forward to the figure of Iris in the west pediment and the selvage of the centaur's cloak shows the 'pie-crust' edging that is to be one of the hallmarks of the Parthenon style as seen in the frieze.

In a nearby metope, no. XXXI, these standards are not maintained. The composition is dull, the poses stiff, the anatomical detail linear and old fashioned. The centaur's face is a grotesque mask and the Lapith's is lifeless. Even the execution is below standard: the centaur's right arm broke off and had to be replaced with a new one dowelled in.

Shortcomings in composition, style and technical skill seem to go hand in hand, just as brilliance in these different aspects of a sculptor's ability are also found together. We need not be surprised that some of the

22 *below left* A centaur prances in triumph over a fallen Lapith. South metope XXVIII.

23 *below right* An elderly centaur abducts a young girl. His long tail was mainly carved free from the background, but a stump of marble in the lower left corner shows where it was attached. South metope XXIX.

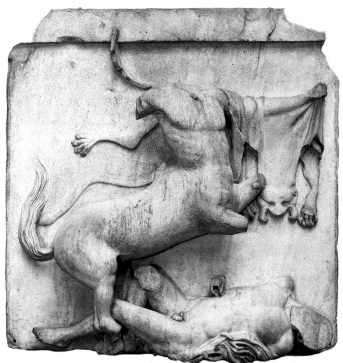

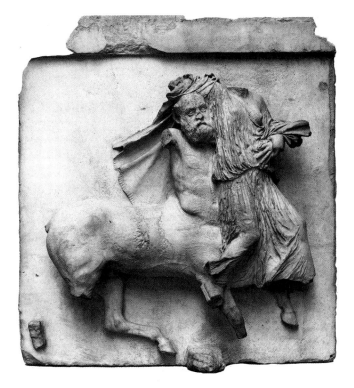

sculptors of the metopes seem at best old fashioned, at worst barely competent. Really skilled sculptors must have been in short supply and there were deadlines to be met. As time went on the less skilled were evidently weeded out, and we shall see the emergence of a more uniform 'Parthenon style' as the better sculptors were welded into a team. If the chronological limits of the work on the metopes were not well documented, we might imagine that some of the more old-fashioned metopes were simply older, perhaps the products of the previous generation. Instead we have to realise that stylistic development is neither simple nor uniform, and that men of differing ages, temperaments and abilities could work side by side on the same monument, producing work of very disparate quality.

The Frieze

Set high up under the ceiling of the colonnade and running around all four sides of the cella building, the Parthenon frieze was almost 160m long and barely 1m high. Of its original length, just under half is in the British Museum (mainly but not entirely acquired from Lord Elgin), about one-third is preserved on the building itself or in other museums, principally the Acropolis Museum in Athens, and almost a fifth was destroyed by the explosion of 1687 and subsequent damage. Of the missing portions, rather over half are known from drawings made before the explosion, so that less than one-tenth of the total is lost without trace.

The design and completion of the frieze presented a host of artistic and practical problems. The enormous length of the frieze in relation to its height demanded a theme for which a large number of participants would be appropriate, and the choice was in practice limited to a battle or a

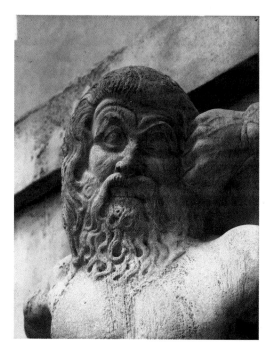

24 *above right* Detail of a Lapith's head from south metope XXXI.

25 *right* Detail of a centaur's head from south metope XXXI.

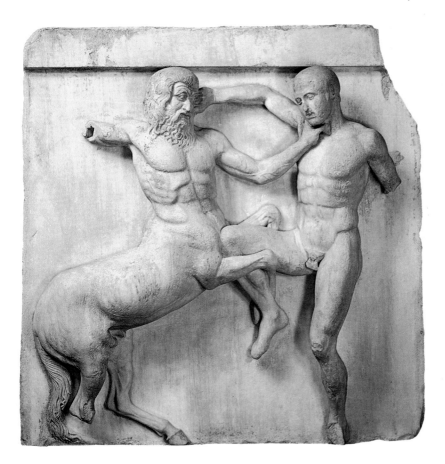

26 A centaur and a Lapith in combat. South metope XXXI.

the bottom, so that the front plane leans forward slightly towards the spectator. The depth of the relief is never more than 6cm but the differential between top and bottom is so consistent that it must result from the order of a single man. When this is taken with the choice of a single subject and the mastery with which it is adapted exactly to the four sides of the building, the unavoidable conclusion is that, although the frieze was actually carved by a large number of individuals, its overall design was the work of one artist. Who it was, we do not know: perhaps Pheidias himself, or at least one of his pupils.

The timing of the work was critical. The frieze-blocks are structural members of the cella wall and had to be available for erection at the appropriate time. From the evidence of the building-inscriptions it seems likely that the frieze-blocks were laid in place around 442 to 440. Unfortunately the surviving fragments of the inscriptions include no reference to the frieze-blocks or to their sculpture. The actual carving was in some ways less urgent than the metopes, which had to be finished on the ground, but the east end of the frieze at least (i.e. the section over the doorway that led to the statue) must surely have been finished by 438. It will certainly have been necessary to decide quite early on whether the frieze should be carved on the ground like the metopes or finished after the slabs were in position on the building. (How this might have been accomplished we shall discuss as we go along.)

The allocation of the different parts of the subject to the four sides of the building must also have been settled at the beginning. As can be seen on the plan (fig. 27), the west 27 frieze shows preparations for the procession, which then moves from west to east simultaneously along both sides of the

procession. There were precedents for both, but what was unprecedented on a Greek temple was the choice of a non-mythological subject and the decision to integrate all four sides of the frieze into a single composition with a single theme. In practice the theme itself was not far to seek: the Panathenaic procession, in which the people of Athens brought a new robe for the statue of Athena every fourth year.

A practical problem was to mitigate the difficulty of actually looking at a frieze carved in low relief and set so high above the ground. The use of colour, including blue for the background, must have helped, but the relief is cut deeper at the top than at

Horsemen Chariots Elders Musicians Pitcher- & tray-bearers Victims

NORTH FRIEZE

Maidens & marshals

Heroes

Gods

Preparations WEST FRIEZE EAST FRIEZE Peplos incident

Gods

Heroes

Maidens

SOUTH FRIEZE Marshal

Horsemen Chariots Elders Tablet- & tray-bearers Victims

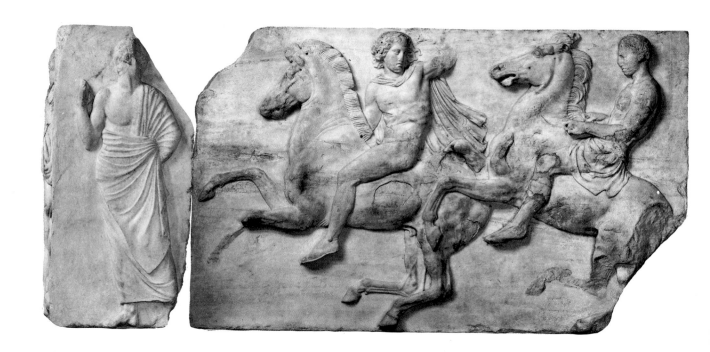

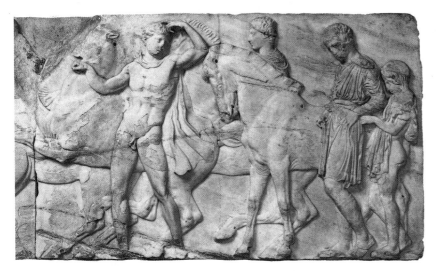

27 *opposite, top* Plan of the frieze showing the participants in the ceremonies.

28 *opposite, below* A marshall and two riders at the end of the west frieze, slabs I (the narrow end of north frieze slab XLII) and II.

29 *above* Two horsemen about to mount and join the procession. The boy on the right, adjusting the rider's tunic, is the last figure on the north frieze, slab XLII.

building to the east end, where it is received by the gods and where we see the peplos itself. The slabs of the frieze are conventionally given roman numerals from left to right according to their original position on the building, while arabic numerals have been allotted to the individual human figures (the animals are not numbered).

Today as in antiquity a visitor entering the Acropolis by the main gateway, the Propylaea, approaches the Parthenon from the west, where the frieze shows a group of men and youths getting themselves and their horses ready for the procession, mounting and beginning to move off. Most of the west frieze is still in place on the building: Elgin removed only the first two slabs at the northern end and had casts made of the rest. Slab I forms the narrow end of the last slab of the north frieze and has space for only a single figure, one of the many officials responsible for marshalling the procession. Slab II shows two youths already mounted and cantering off to join the procession, one of them gesturing with his left hand to his head. Differences in style, especially in their faces and in the

treatment of the horses' manes, suggest that they were carved by different hands. The subject is self-contained within a single slab, as is the usual practice in the west frieze, where there is hardly any overlap from one slab to the next. These slabs could easily have been carved on the ground like the metopes before being laid in place above the architrave. They would then have been carved fairly early in the series, before about 440 BC. The figures show a great variety of action and dress, as if the instructions given to the sculptors by the designer were not very detailed. The actual slabs vary in length, and it is perhaps more likely that they were cut to specific sizes to fit the design than that the design was adapted to slabs of random length.

Although some of the men and horses on the west frieze face the spectator's right, all the mounted horses are being ridden to the left, towards the angle with the north frieze. This is because the most direct route from the Propylaea to the main, eastern doorway of the Parthenon runs past the north rather than the south side of the temple. Inevitably the north frieze will have received more attention than the south. The end slab of the north frieze is longer than most of the rest and shows the last of the horses that are still to be mounted. One of the youths who has yet to mount restrains his rearing horse with his right hand, repeating with his left the gesture of the rider on the west frieze. He is nude, apart from a cloak (*chlamys*) loosely fastened around his neck and flowing behind. His nudity is an artistic convention, repeated many times in this section of the frieze. His companion is fully dressed in a short tunic (*chiton*) and boots. The *chiton* is girt at the waist and the folds are being adjusted for the parade by a young boy, the last figure on the north frieze.

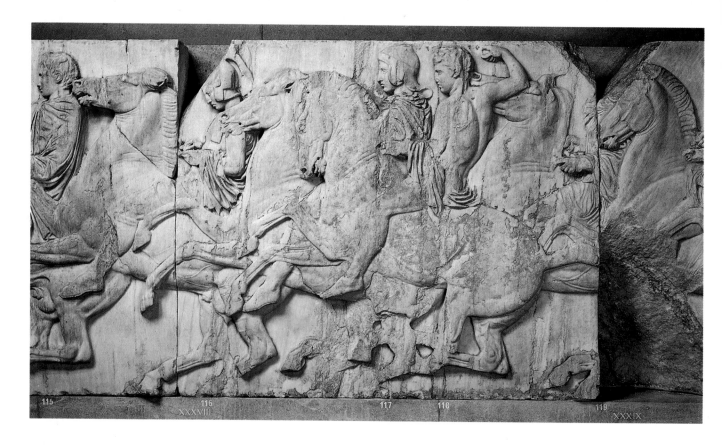

The next twenty slabs of the frieze, almost half the length of this side, were occupied by the horsemen. They move off at a smart trot, occasionally breaking into a canter but checking the pace to keep rank. By showing the ranks in echelon, with the horses overlapping but not directly behind one another, the artist has been able to represent groups of horsemen five, six and even seven abreast. Although many sculptors did the actual carving, the design must have been worked out by a single designer. In both design and technique this was a remarkable achievement, especially as the actual depth of the relief is severely limited. An essential feature of the low-relief technique was to cut back very sharply from the front surface around the contour of the nearer figures. Those further away are shown in lower relief against the background.

Throughout this section of the frieze there is great variety of action and movement, but the horses are not frozen in position as if photographed by a high-speed camera. Instead the artist has extracted from his visual memory various features of horses' gait and has blended them into an artificial but convincing posture. The hind-legs are consistently bent to bring the horses' bodies lower and leave space above them for the riders. For the same reason and to keep at about the same level the heads of horses, riders and men on foot, the relative scale of the horses has been subtly

30 *above* Riders in the procession. North frieze slab XXXVIII, with parts of adjacent slabs.

31 *opposite, top left* Detail of two riders, one wearing a fur cap. North frieze slab XXVIII, numbers 117 and 118.

32 *opposite, top right* Riders in the procession. North frieze slab XXVIII.

33 *opposite, below* Riders in the procession. North frieze slabs XXXVI and XXXVII.

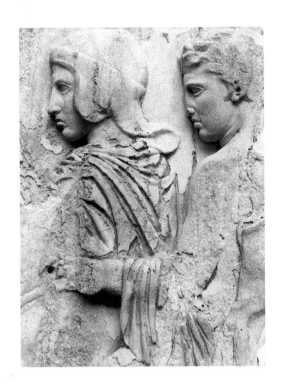

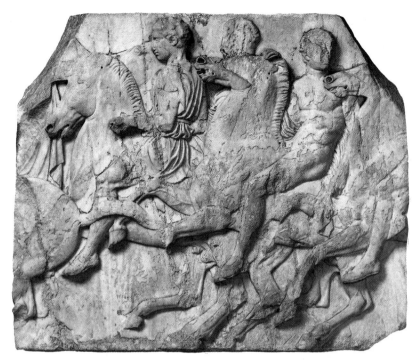

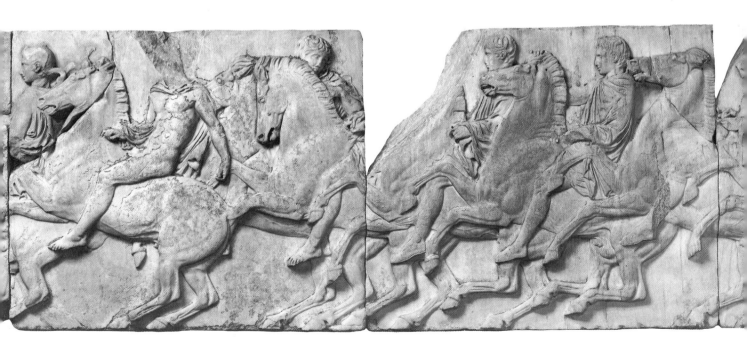

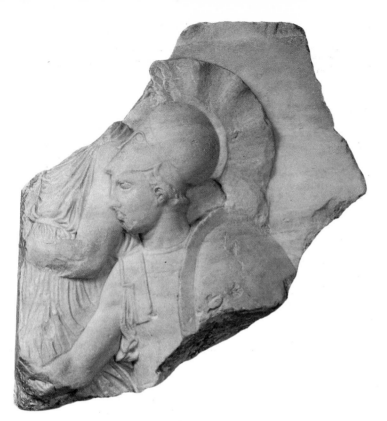

34 Fragment damaged in the explosion of 1687. The drapery on the left is the chiton of a charioteer, whose passenger is to be seen on the right, armed with helmet and shield. North frieze slab XXII.

Surviving traces of the original face of the slabs show a uniform claw-chiselled surface such as would be normal when a block that was dressed to size but not yet finally smoothed was laid in its place. The overall design could easily have been sketched on this surface by the artist before his assistants set to work on the actual carving.

Ahead of the riders the procession consists of a group of four-horse chariots, each driven by a charioteer with an armed soldier as passenger. The charioteers wear their traditional costume, an ankle-length *chiton*. The soldiers, known as *apobatai*, leapt on and off the moving chariots in a demonstration of agility and skill. This was a ceremonial rather than a practical military manœuvre, since in the fifth century the Greeks did not use chariots in battle.

This spectacular demonstration as well as the charge of the horsemen took place at an early stage of the procession. The route along the Sacred Way led from the Pompeion, the 'procession-building' near the Sacred Gate, across the Agora and up the hill of the Acropolis. Since neither chariots nor horsemen could conveniently negotiate the slope, their great moment came in the Agora itself.

This section of the frieze suffered badly in the explosion of 1687 and several of the slabs are missing or survive only in fragments. In the next section, where the participants are all on foot, the damage was even worse, so that in some parts our knowledge of it is derived largely or wholly from the old drawings. Here the frieze showed a group of elderly men, musicians playing the *kithara* (a stringed instrument like a lyre but with a wooden sounding-box) and the double pipes, young men carrying water-jars (*hydriai*) or trays of offerings, and cattle and sheep to be sacrificed. These details do not correspond exactly with

diminished. Among the riders there is a variety of dress as well as of movement and gesture. Some riders are naked, barefoot and bare-headed; others wear tunics or cloaks, boot or sandals, and a variety of headgear including fur caps. Some even wear the helmet and cuirass more appropriate to the heavy infantryman (hoplite).

The slabs of the north frieze average 1.22 m in length, but in this section the sculpture takes no account of the divisions between the slabs. Important features like riders' heads are not normally divided between one slab and the next, but otherwise the sculpture unfolds continuously. This implies not only that there was a single designer to co-ordinate the work of several sculptors but also that the sculpture was not executed until the actual slabs were already in their final places on the building.

35 Surviving section of a slab damaged in the explosion of 1687: a youth carrying a tray of offerings on his shoulder. North frieze slab V, 13.

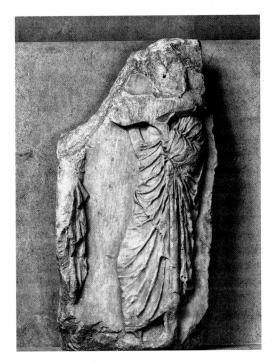

accounts of the Panathenaic procession preserved in the ancient literary sources: the water-jars are reported to have been carried in the procession by girls, but a slab of the frieze, extracted from a Turkish building that was demolished after Greek Independence and now in the Acropolis Museum, confirms that the Carrey drawing was correct in showing boys. The drawing 36 of the adjacent slab when it was complete enables us to identify and place the surviving 35 fragment showing a boy with a tray of offerings.

The south frieze repeats the subject of the north frieze, but here the procession moves from left to right rather than from right to left, almost as if it were seen from the other side of the street. The subject is repeated rather than imitated exactly. There are more riders on the south than on the north but fewer chariots. It seems there are no musicians as on the north frieze, for the

36 Drawing attributed to Jacques Carrey showing the condition of north frieze slab V in 1674. Paris, Bibliothèque Nationale.

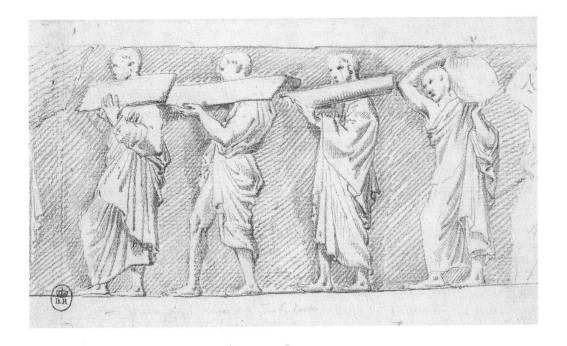

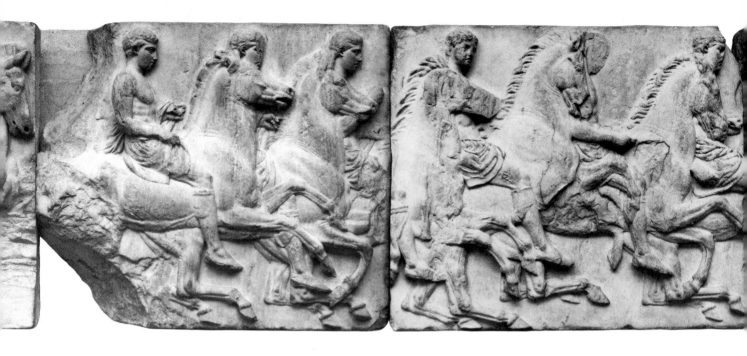

37 *above* Riders in the procession. South frieze slabs X and XI.

38 *right* Riders in the procession. The treatment of the horses' manes suggests that slab XXX (title page and fig. 40) was carved by the same sculptor as this one, south frieze slab III.

39 *opposite, above* An *apobates* with a shield walks beside his chariot: dowel-holes show where parts of the harness were added in bronze. In the background, a marshall points towards the rear of the procession. South frieze slab XXV.

40 *opposite, below* A chariot at speed. The flame-like treatment of the horses' manes is very like that on slab III (fig. 38), suggesting that the same sculptor also carved this slab, south frieze XXX.

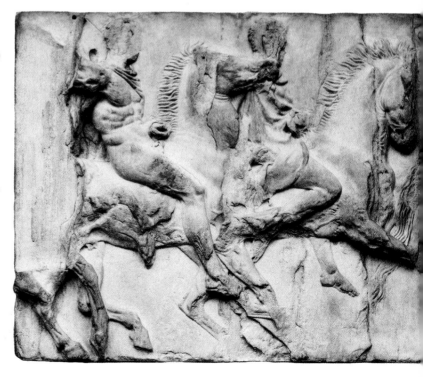

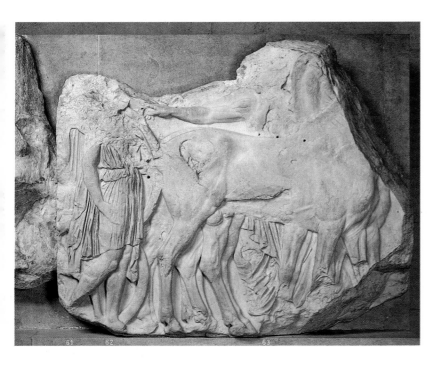

men in the corresponding section on the south, where the original slabs were totally destroyed by the explosion, appear in the Carrey drawing to be carrying rectangular objects that Frank Brommer interprets as tablets.

The composition, especially of the cavalcade, is simpler, the action is less exciting. 37 The standard of the sculpture too is in general below that of the north frieze. There are several possible reasons for this. Since the south frieze, like the south metopes, is less conspicuous than the north, it may have been a deliberate policy to employ on it the less able sculptors. Work on it may have been postponed when there was more important work to be done – only to be completed in a hurry against a deadline. Whatever the reason, it is clear enough that many different hands were at work: the markedly different treatment of details like the dressing of horses' manes can be seen to vary almost slab by slab. None the less, some of the sculptors in this section were more inspired, as the lively horses of slab III show with their tossing 38 heads and flame-like manes.

As well as being fewer in number than those on the north frieze, the chariots on the south each occupy a shorter space, a single slab. One of them has slowed almost to a standstill, the *apobates* walks beside it and 39 beyond the horses a marshal gestures with outstretched hand. By contrast a neighbouring chariot is shown at full tilt, the 40 horses at a gallop and the *apobates* on board the chariot, his drapery flowing out behind. The horses themselves, perhaps by the same sculptor as those on slab III (the carving of their manes is very reminiscent of it), have been graphically described by John Ruskin:

The projection of the heads of the four horses,

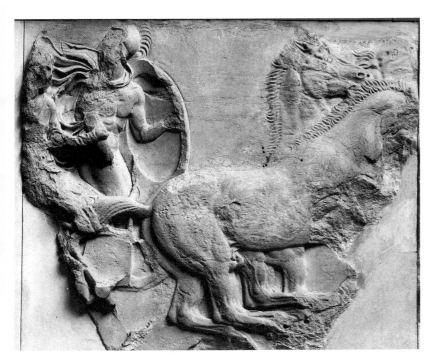

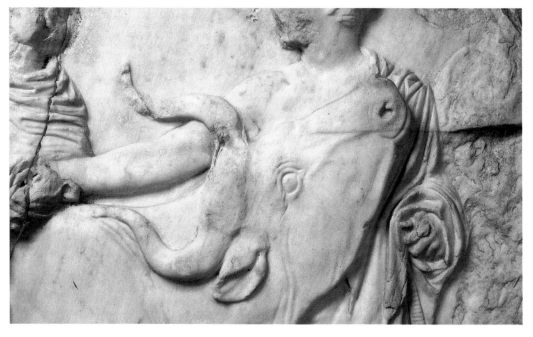

41 Head of a heifer. It is generally believed that Keats had this detail in mind when he wrote of 'the heifer lowing at the skies'. South frieze slab XL.

one behind the other, is certainly not more, altogether, than three-quarters of an inch from the flat ground, and the one in front does not in reality project more than the one behind it, yet, by mere drawing, you see the sculptor has got them to appear to recede in due order, and by the soft rounding of the flesh surfaces and modulation of the veins he has taken away all look of flatness from the necks. He has drawn the eyes and nostrils with dark incisions, careful as the finest touches of a painter's pencil: and then, at last, when he comes to the manes he has let fly hand and chisel with their full force, and where a base workman (above all, if he had modelled the thing in clay first), would have lost himself in laborious imitation of hair, the Greek has struck the tresses out with angular incisions, deep driven, every one in appointed place and deliberate curve, yet flowing so free under his noble hand that you cannot alter, without harm, the bending of any single ridge, nor contract nor extend a part of them.

The sacrificial victims on the south side include no sheep but only heifers. One makes an almost successful attempt to break free, causing some consternation to the man leading the next, which raises its head. This beast is traditionally identified as the one that inspired Keats to write of 'that heifer lowing at the skies' in his *Ode on a Grecian Urn* (which seems to derive its imagery from several pieces of sculpture, including a Neo-Attic marble vase). Both this herdsman and the marshal beyond have the 'pie-crust' selvage on their cloaks that is almost a trade-mark of the Parthenon sculptors.

As we turn the corners from the long north and south sides of the frieze to the shorter east end the whole character of the scene changes. The excitement of the cavalcade, the rattle of the chariots, the sound of musical instruments and the bustle and clamour of the sacrificial animals are left behind. Instead we have the calm of a sacred ceremony in the presence of the gods, and women appear on the frieze for

the first time. The composition is symmetrical, with the gods seated in two groups flanking a ceremony in the centre, and with the procession approaching them at a slow and dignified pace from both sides.

Although the gods are shown seated, their heads are seen at about the same level [42] as the mortals who approach, so that they are in fact represented, as is appropriate, on a larger scale. They are readily identified by their gestures and their attributes. At the end of the row on the left sits Hermes, the messenger, wearing a cloak and boots, with his travelling hat (*petasos*) on his knee. In his right hand he once held his herald's staff (*caduceus* or *kerykeion*), but this was added in metal and all that now remains is the hole into which it slotted. Sitting beside him and leaning on his shoulder in a companionable way is Dionysos, god of fertility and especially of wine. He sits on a cushion and his left hand is raised to grip the shaft of his *thyrsos* (an ivy-wreathed fennel stick), which must have been shown in paint since there are no dowel-holes for a bronze attachment. Facing Dionysos is Demeter, the goddess of corn. She raises her right hand to her chin in a gesture of mourning for her lost daughter Persephone, who was carried away for half the year by the god of the Underworld. In her left hand she holds the torch she used to search for her daughter: the lower part is preserved but a projecting lump of marble higher up shows where the top was joined to the background. In a relaxed posture next to her is Ares, god of war. The end of his spear can be seen in relief against his right heel, but the rest must have been shown in paint.

The next seated figure is Hera, consort of Zeus, raising her veil to him in the traditional gesture of the bride. Between her and Ares stands Iris, the winged messenger. Zeus has the place of honour at the end of the row, and he alone sits not on a stool but on a throne with a back and arms, the arm supported at the front by a tiny seated sphinx. In his left hand he originally held a sceptre.

In the corresponding place of honour on the other side sits Athena, for this is her [43] temple. On this occasion she appears without her helmet but she holds her snake-fringed aegis in her lap and had a spear in her right hand, its original angle indicated by a row of dowel-holes. Beside Athena sits Hephaistos, a fellow-patron of craftsmanship, who shared with her a temple near the Kerameikos. A stick under his right armpit reminds us that he was lame. Next came Poseidon, Apollo and Artemis, and finally Aphrodite and Eros, now sadly in fragments and better known through a cast made around 1790.

Between the two groups of gods are five humans engaged in a ceremony that must have been perfectly intelligible in antiquity but perplexes the modern spectator. The action is clear enough: two girls carrying on their heads stools with cushions (most of the legs of the stools are missing) approach a woman; standing behind her, a man and a child are holding a folded piece of cloth. The woman must be the priestess of Athena, the man the Archon Basileus, the chief official of the state religion; the stools are probably for their use, and the cloth must be the peplos itself. Where this takes place, what is to happen next and what the action signifies remain a puzzle. Even the sex of the child is in doubt. Usually the figure is interpreted as a boy, but the dress (probably an ungirt peplos, a woman's tunic) and the indication of 'rings of Venus' on the neck have prompted Martin Robertson to suggest that this is in fact a young girl, as James Stuart believed in the eighteenth century.

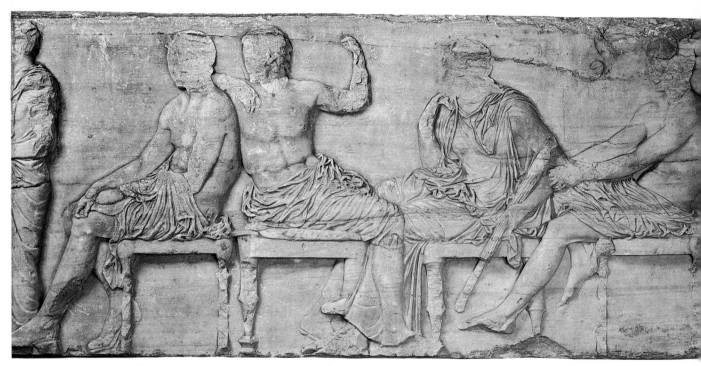

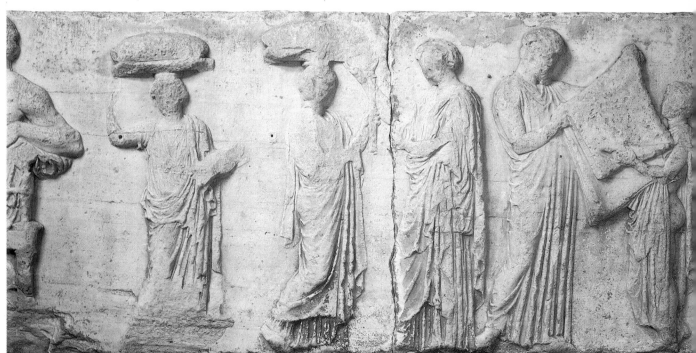

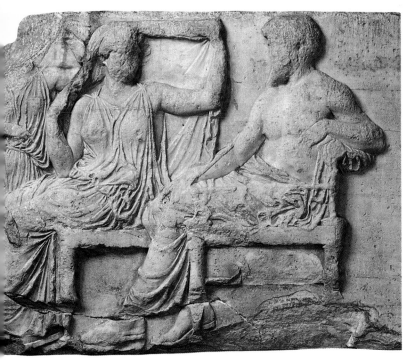

42, 43 The central section of the east frieze. Above, from left to right, Hermes, Dionysos, Demeter, Ares, Iris (standing), Hera and Zeus; below, two girls carrying stools, the priestess of Athena, the Archon Basileus and a young girl holding the *peplos*; Athena and Hephaistos seated. East frieze part of slab IV and slab V.

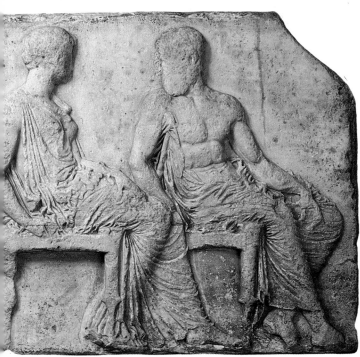

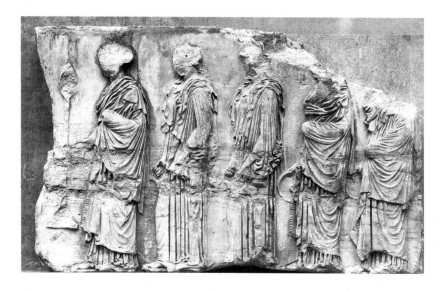

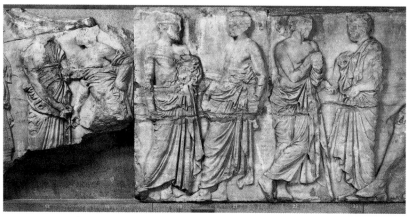

The gods, moreover, turn their backs on this incident and face the approaching procession, which converges from both sides, led by groups of young women. Some of them carry vessels for pouring offerings 44 of wine to the gods: jugs (*oinochoai*) and libation bowls (*phialai*). One carries an incense-burner (*thymiaterion*) on a tall stand, others have less easily recognised burdens: stands with spreading bases that may have been dogs to support the spits on which the sacrificial meat was roasted, parts of the loom on which the peplos was woven, or something else that a fifth-century Athenian would have recognised at once. The girls at the head of each group are empty-handed. Perhaps they carried the peplos, now in the hands of the Archon Basileus. They may even represent the *Arrephoroi*, the maidens responsible for setting up the loom.

Between the girls in the procession and the seated gods are two groups of standing 45 men. Some are evidently marshals like those we have seen elsewhere on the frieze but the rest have not been identified with certainty. They may simply be representative citizens but are more likely to be the Eponymous Heroes of the ten tribes or perhaps the chief magistrates of Athens, the Nine Archons, depending on how many of the rest are counted as marshals.

It can hardly be denied that the subject of the frieze is the Panathenaic procession, but it is equally clear that this is hardly a straightforward representation of what happened on a particular occasion. The conventional interpretation sees the preparations on the west frieze as happening at the Pompeion, the main part of the procession on the north and south friezes as following the route of the Sacred Way towards the Acropolis, and the culmination of the ceremony on the east frieze as taking

44 *top* Girls near the head of the procession carrying vessels for the sacrifice: most hold libation-bowls or jugs, but the leader has an incense-burner on a tall stand. East frieze slab VIII.

45 *above* Men standing near the gods: it is not clear whether they represent private citizens, the magistrates (Archons) or the Eponymous Heroes of the ten tribes. East frieze, parts of slabs III and IV.

place on the Acropolis itself. In a work of art of this kind and of this period we should not look for a strict observance of the unities of time and place, but the speed of the horsemen is incompatible with the pace of those on foot, who even seem to stop and start again. There is in the whole scene, as Martin Robertson has pointed out, a feeling of preparation and beginning rather than of completion.

It is surprising to find that the whole company of gods has made an appearance at a ceremony in honour of Athena, and it is not clear why so many of the young women carry libation bowls to a sacrifice for a single goddess. Perhaps more significant are the missing elements. The evidence about the Panathenaic procession in ancient literature tends to be rather sketchy and to come from much later sources, but some details are clear. That the *hydriai* and baskets should be carried by girls rather than youths is a minor point: perhaps the custom changed over the years. A much more important omission from the frieze is the parade of hoplites, the Athenian citizens in their armour. At the same time the cavalrymen and the chariots take up about two-thirds of the total length of the frieze.

No convincing explanation for the absence of the hoplites was advanced until John Boardman suggested a radically new interpretation of the action and occasion of the frieze. The concentration in the frieze on horses, both mounted and drawing chariots, is the crucial clue, for horses are always associated in Greek tradition with the concept of heroisation. Horses are represented in the monuments of heroes and when the greatest Greek hero of all, Herakles, is admitted to the company of the gods, he goes in a chariot. The horsemen in the cavalcade appear to ride in ten groups, perhaps representing the ten tribes, and

some of them wear hoplite armour. Here, then, are the hoplites that are known to have taken a prominent part in the real Panathenaic procession, but represented as heroes. They are on their way to be presented not simply to Athena but to the whole assembly of gods, who turn to watch them approach, ignoring (it seems) the ceremony with the peplos that ought to be the culmination of a normal Panathenaic procession.

Who then are these heroes? Whom would the Athenians choose as the greatest heroes of the age? There is no doubt that throughout the fifth century, when the Athenians looked back to the perils of the Persian invasions, their greatest heroes were that small but valiant band who overcame enormous odds to repulse the Persians in 490, the *Marathonomachoi*, the men who fought at Marathon. Those who fell in the battle were buried on the field under a mound of earth and there is some evidence of a hero-cult there in their honour. If the subjects of the metopes of the Parthenon are to be explained as allegories of the Persian Wars, it need not surprise us to find on the frieze a scene of the formal presentation to the gods of the men who fell at Marathon.

Pausanias records the tradition that the gods fought alongside the Athenians at Marathon, and even before the Parthenon was built there was a painting of the Battle of Marathon in the Painted Stoa in the Agora showing gods, other mythological heroes and Athenians together on the battlefield. The Great Panathenaia was celebrated in 490, only a few weeks before Marathon, and the men who fell there no doubt took part in the procession. On the frieze we see them taking part again in the chief festival of their city's patron goddess, and at the same time being received as heroes by the gods.

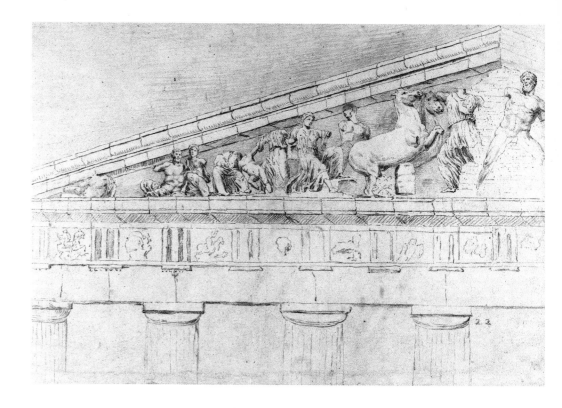

Although the frieze is damaged and the number of men shown on it is not certain, it seems likely that those taking part in the procession as riders, *apobatai* and marshals (but not the charioteers) totalled 192, precisely the toll of Athenian dead as reported by Herodotus. This could be the result not of coincidence but of deliberate calculation.

If this interpretation is correct, the culmination of the ceremony is not on the Acropolis, where Athena reigned, but in the Agora, where the Twelve Gods had their altar, where the Eponymous Heroes had a sacred precinct, where the cavalry charge and the chariot demonstration of the Panathenaic procession took place. The priestess of Athena and the Archon Basileus are present, the latter receiving the new peplos from the hands of one of the *Arrephoroi*.

The Pediments

It is generally agreed that the pedimental figures were the last of the sculptures of the Parthenon to be carved. From the building-inscriptions it is all but certain that the first payments to the sculptors for carving them were made in 438, the year when the temple was dedicated. Certainly the sculptures could not be set in place before the structure was complete, but work on the design must have started earlier so that blocks of marble of suitable dimensions

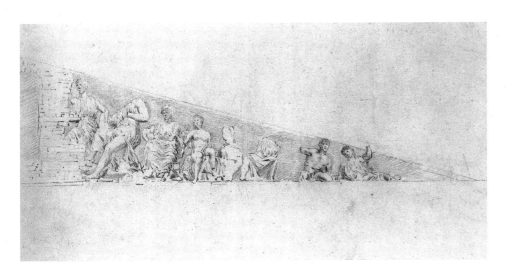

46, 47 The west pediment of the Parthenon in 1674 (facsimiles of drawings attributed to Jacques Carrey).

could be ordered from the quarries. The last payments for loading marble at the quarries were made in 434, and the sculptures must have been carved, painted and set in place by 432, when the accounts end. To produce about fifty statues, all over life-size, in five or six years again required a large team of sculptors, but the design and composition of each pediment must have been entrusted to a single artist.

The subjects of the pediments are known from Pausanias, who wrote a guide book to Greece in the second century AD: on the east, the birth of Athena; on the west, her contest with Poseidon for the land of Attica. This is all Pausanias says about the pediments, and nothing is added by the other ancient authors. It is much to be regretted that Pausanias did not add a description of the action as he did for the pediments of the Temple of Zeus at Olympia, where even minor figures are described, although some are incorrectly identified. Olympia, of course, unlike the Acropolis, was a Panhellenic shrine, and Pausanias seems to have thought that the Parthenon was not as interesting to his contemporaries as the Temple of Zeus. Although Zeus himself appeared in the east pediment of his temple, the west pediment showed Apollo observing the battle of Lapiths and centaurs. An innovation in the design of the Parthenon was the choice for both pediments of scenes involving the temple's patron goddess.

The contest between Athena and Poseidon was an unusual subject (first recorded by Herodotus), which gave the designer a free hand in the composition. The result is best seen in the Carrey drawing, for in 1674 the pediment was still almost complete. It is not clear whether the explosion of 1687 damaged any of the sculptures, but the chariot-horses from the left side were shattered by Morosini in an unsuccessful attempt to remove them. Part of the head of one eventually reached the Vatican, but the corresponding pair from the other side of the pediment had been removed before Cyriac of Ancona visited Athens in the mid-fifteenth century, and their fate is unknown. Parts of some figures, perhaps broken in the explosion, were lying on the pediment floor

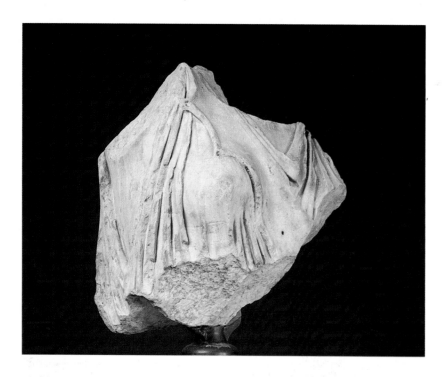

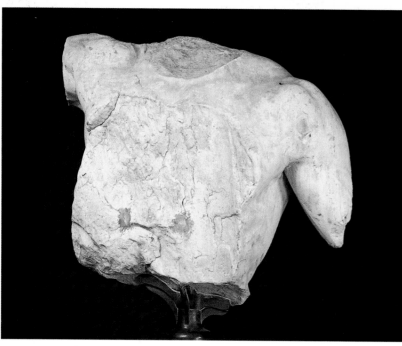

at least as early as 1749 and were later removed for Lord Elgin.

The Elgin Marbles include the torsos of the protagonists, Poseidon and Athena, 49 identified by the aegis on her breast, with a 48 dowel-hole for the attachments of a gorgon's head. According to the myth the two divinities met on the Acropolis and each worked a wonder to support their claims to the land. Poseidon struck the ground with his trident and produced a salt spring, Athena struck with her spear and brought forth the first olive tree. Athena was the winner, although the ancient authorities differ on who gave judgement and on what grounds. The mark of Poseidon's trident was still shown in the Erechtheion in Pausanias' day (it may be identical with a fissure in the rock below the north porch, left open to the sky through holes in the floor and the roof), and an olive tree always grew in the nearby precinct of Pandrosos. Athena's head was already missing by 1674 but a fragment including part of her helmet 84 is preserved in the Acropolis Museum as well as the front part of Poseidon's chest. As the drawing shows, the two figures formed the centrepiece of the pediment, opposed to each other but moving apart in a composition around diagonal lines that intersect near the base. The scheme is reminiscent of south metope XXVII. Between the two figures was Athena's olive tree.

Athena and Poseidon have evidently arrived on the scene in two-horse chariots. The horses are rearing up, being reined in by the charioteers, and nicely fit the line of the raking cornice. Athena's charioteer no longer survives but the body of Poseidon's 50 charioteer can be recognised from the Carrey drawing, where it is identified as Amphitrite, Poseidon's consort, by the sea-serpent at her feet. (Fragments of the sea-serpent in Athens have been recognised by

48 *opposite, above* Torso of Athena. The dowel-holes were for metal attachments to the aegis: snakes at the edge and the gorgoneion (head of Medusa) in the centre. West pediment L.

49 *opposite, below* Torso of Poseidon. This figure was still almost complete in 1674. West pediment M.

50 *right* Amphitrite, the consort of Poseidon. She wears a long chiton, fastened with a wide belt below her breasts, since she is serving as Poseidon's charioteer. West pediment O.

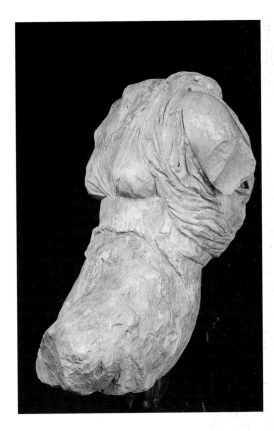

Nicholas Yalouris.) Amphitrite appears as Poseidon's charioteer elsewhere in Greek art, including one of the east metopes, immediately below the pediment. The goddess wears a peplos girt with a belt high below the breasts and open at the side so that, as the drawing shows, the lower part was swept back by the wind, leaving the left leg bare.

Both protagonists were accompanied by divine messengers, Athena by Hermes, Poseidon by Iris. In the drawing Hermes can be seen looking back over his shoulder. His head had disappeared by 1749, and only his battered torso survives, a sad remnant of 51 what was once a splendid and powerful sculpture. The torso of Iris can be identified 52

by the rectangular sockets in her shoulder-blades, where her wings were once attached. According to Visconti this figure was found 'on the floor of the east pediment' and it has been thought to belong to that end of the building. Visconti must simply have been in error, for the figure is clearly recognisable in the Carrey drawing, and later drawings show fragmentary sculptures on the floor of the west pediment but not of the east. Iris wears a short tunic of fine material, pressed against her body by the wind, rippling in a myriad of tiny folds and fluttering away behind. It was held at the waist by a girdle, once added in bronze and now missing. It must once have been among the finest of the pedimental figures, and even now, in fragments and incomplete, it continues to excite admiration.

In the absence of positive information the identity of most of the remaining figures remains conjectural. The story is a local Athenian myth, and the figures certainly included King Cecrops, recognisable because his lower parts took the form of a serpent. This figure was left in the pediment by Elgin's agents because it was then thought to be a Roman replacement and was removed to the safety of the Acropolis Museum in 1976. One of the smaller fragments in the Elgin Collection is part of the snake. The names of other members of this crowded and complex scene can only be guessed at. Bernard Ashmole has even wondered: 'Did anyone, even in antiquity, remember who they all were?' Pausanias, at least, does not tell us, even if he knew.

The reclining male figure in the extreme left angle of the pediment is often identified 53 as a river god, on the analogy of similar figures in the angles of the east pediment of the Temple of Zeus at Olympia, whom Pausanias names as the local rivers, Alpheios and Kladeios. Support is given to this

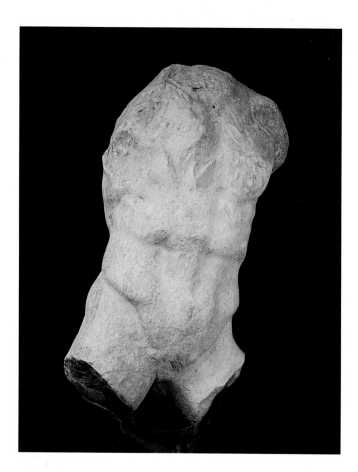

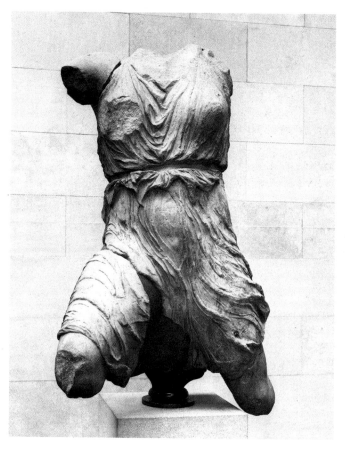

suggestion by the sculptural treatment of the left leg, which seems to disappear into the ground – or rather flow out of it. The name conventionally given to the figure is Ilissos, one of the rivers of Athens, flowing (now largely through a covered conduit) to the south of the Acropolis. He is caught momentarily in a twisting movement as he raises his body on his left arm and looks round to discover the cause of the commotion in the centre of the scene. Complex and well observed though the posture is, there is no undue concentration on mere anatomical detail; bones, muscles and skin are realised in stone by a sculptor of great sensibility and consummate skill.

Behind Amphitrite's chariot is a seated female figure, seen in the Carrey drawing to ₅₄ hold two children. The most likely identification is Oreithyia, known in Attic tradition as the daughter of the legendary King Erechtheus, who bore the twins Kalais and Zetes to Boreas, god of the north wind. Even though she sits immobile, her dress seems to be disturbed in the wind.

Unlike the west pediment, the east pediment suffered little damage in the aftermath of the explosion, its worst disaster having happened many centuries earlier, when almost half of its total length (and

51 *far left* Hermes. This figure originally stood at the back of the pediment, beyond Athena's chariot. West pediment H.

52 *left* Iris. The fragment with the right thigh and knee was identified as part of this figure in 1860. The figure was once incorrectly assigned to the east pediment, but in 1874 it was recognised as west pediment N.

53 *below* Figure of a river-god from the left corner of the pediment, usually identified as Ilissos. West pediment A.

54 *right* Lower part of a seated female figure, perhaps Oreithyia, seen from the front. The line of her legs may be seen beneath the billowing drapery. but her feet have been broken off at the ankles. West pediment Q.

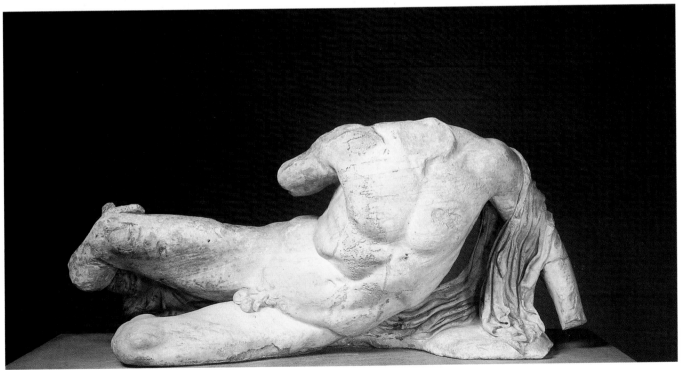

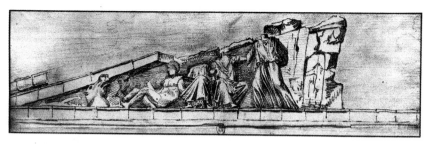

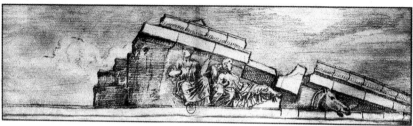

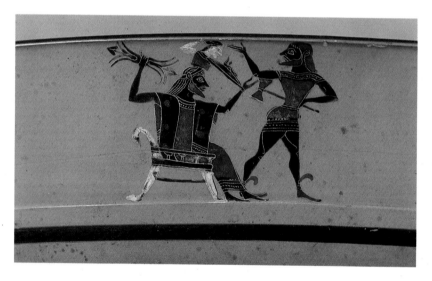

55 *top* The outer ends of the east pediment of the Parthenon as seen in 1674. Drawing attributed to Jacques Carrey. Paris, Bibliothèque Nationale.

56 *above* The birth of Athena from the head of Zeus; on the right, Poseidon with his axe. Detail of a black-figured drinking-cup, made in Athens about 550-540 BC. *British Museum Catalogue of Vases* B 424.

much more than half of its sculpture in bulk and importance) was removed in connection with the conversion of the temple to a church. Two of the heads still seen in the Carrey drawings had been lost by 1765 when William Pars visited Athens (see contents page) and one statue had fallen over, but otherwise the sculptures in the Carrey drawings are those removed for Lord Elgin. A few sculptures, including some fragments thought to belong to the central group, having fallen earlier, were excavated after Greek Independence and are now in the Acropolis Museum.

The loss of the central section would have made the subject unrecognisable if Pausanias had not noted that it was the Birth of Athena. Even with that knowledge, most of the surviving sculptures cannot be identified with certainty since the subject had fallen out of fashion in the classical period and the subsidiary figures do not correspond in detail with those in the archaic representations. The myth itself was hardly one to appeal to sophisticated fifth-century taste, although it had been a popular one in the archaic period, especially on vases. The story is at least as old as Hesiod: Zeus lay with Metis (Thought), and then fearing that she might bring forth something stronger than his thunderbolt, swallowed her whole. In due time Athena was born, already fully armed. According to later tradition she sprang from the head of Zeus, which Hephaistos had split open with his axe. It was a subject sure to appeal to the naïve mind, and archaic artists used it often, either showing simply the principal characters or adding others, including Poseidon and the Eileithyiai, goddesses of childbirth. Artistically it was a strange choice after 450 BC, but justified by the policy of making all the sculptures of the Parthenon relevant to Athena and her city, and also because

57 The birth of Athena: the newly born Athena, fully armed with helmet, shield and aegis, is crowned by Nike (Victory); behind the throne of Zeus stands Hephaistes with his axe; at the left, the three Fates. The figures are carved in relief around a Roman altar in Madrid.

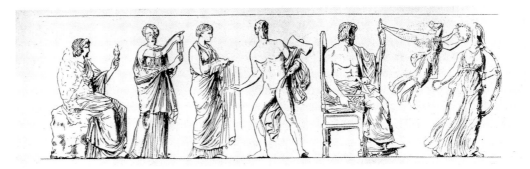

Athena's birthday was the occasion of the Panathenaic festival.

The loss of the central group and the absence of any reference to its composition in the surviving ancient literature make its appearance a matter of conjecture. Many scholars believe that some or all of the figures carved in relief on a circular marble 57 altar of Roman date are derived from those of the east pediment, since they obviously imitate a Greek work. (The altar, now in Madrid, was later hollowed out to serve as a well-head and is therefore often called 'the Madrid puteal'.) It shows the three Fates, who were believed to be present at every birth, Hephaistos with his axe, Zeus seated on a throne and Nike (Victory) flying to crown Athena. It makes a very credible extract from a pedimental composition, with Zeus seated in the centre, Athena and Hephaistos moving away in opposite directions but looking back towards Zeus, and with the most distant of the Fates seated as though to fit under the sloping line of the cornice. George Despinis has shown that the same scene was represented on some fragmentary sculptured panels from the Piraeus, which include details suggesting that they were copied from a work of the fourth century BC. This earlier sculpture may itself reflect the composition of the Parthenon pediment, but some scholars see

a connection only in the subject matter and dismiss the Madrid puteal as evidence for the Parthenon pediment. Ernst Berger, for instance, argues that a grouping based on the puteal would be incompatible with the positions of iron bars set into the marble floor of the pediment and evidently intended to take some of the weight of the sculptures, and proposes a different scheme, including chariots. A few words from Pausanias would have settled the matter.

One of the problems that always had to be faced by the designers of pediments was how to deal with the diminishing height towards the angles. Horses or, as at Olympia, centaurs facing the centre could be very useful, but human figures had to be placed in a progressing series of standing, stooping, crouching and seated postures. A standard solution for the outermost position was a reclining figure, as on the west pediment, with the feet in the angle. The artist of the east pediment found a new solution: he dissolved, as it were, the pediment floor in the angles, turning it into a representation of Okeanos (Ocean), the 58 river that was believed to surround the earth, and showed the figures there partially submerged. At the left side Helios (the Sun) is represented as the driver of a four-horse chariot emerging from Okeanos as he did each morning. He reaches forward to

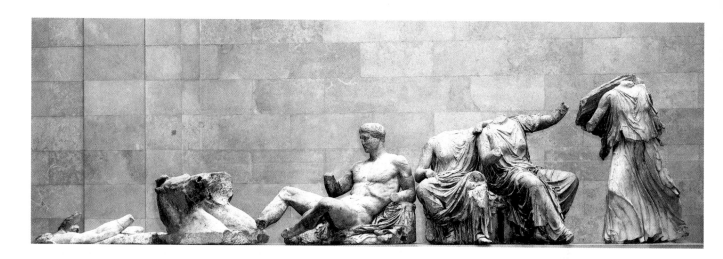

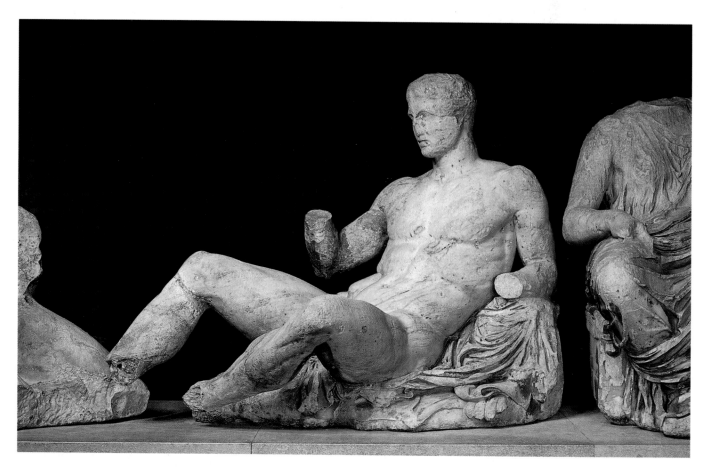

the reins that control his four spirited horses (two among the Elgin Marbles, two left in the pediment). The waves of Okeanos are represented on the upper surface of the marble block, but would of course have been invisible from the ground.

The identification of the remaining figures in this corner of the pediment is much disputed. The first figure on dry land is a male reclining on a rock over which is draped an animal skin, shown by a paw to be one of the larger felines, a lion or a panther. In the early nineteenth century he was identified as Theseus, but most scholars now see him as Dionysos on a panther-skin, or perhaps as Herakles on a lion-skin. The interpretation is partly governed by conjectural restorations of the figures missing in the centre: if Dionysos

were included there, this must have been Herakles. Originally, when the whole scene was visible, there would have been no problem, and the figure may also have been identified by an attribute in his right hand (missing since before 1674), perhaps a *kantharos* (two-handled wine-cup) for Dionysos. This is the only pedimental figure with its head intact.

Next came two female figures, carved from a single block. Each wears a long tunic (*chiton*) of fine, crinkly material under an outer garment of heavier stuff, perhaps wool, which falls in broad, sweeping folds. They are seated on rectangular wooden chests, set at different angles, their tops padded with folded drapery. Their heads have long been lost, as have their hands, which might have held attributes to identify them. They are usually thought to represent Demeter and Persephone, the mother and daughter worshipped as fertility-goddesses at Eleusis, but this identification is far from certain. If the chests are to be taken as those used in the Eleusinian Mysteries, they should have been cylindrical rather than rectangular; and since Persephone was not strictly speaking one of the Olympians, her presence at the birth of Athena is unexpected. In the absence of attributes the problem is likely to remain unsolved.

The same problem arises with the next figure, a young woman rushing to the left as if bringing news of the startling event in the centre of the pediment to those seated and reclining at the side. Since she is not winged she can hardly be Iris, and she is often called Hebe, the cup-bearer of Zeus, although Frank Brommer suggests Artemis as a reasonable identification. Her wind-swept peplos indicates her speed, formerly accentuated by her cloak billowing out behind her and now largely broken away. The sculptor clearly possessed a very

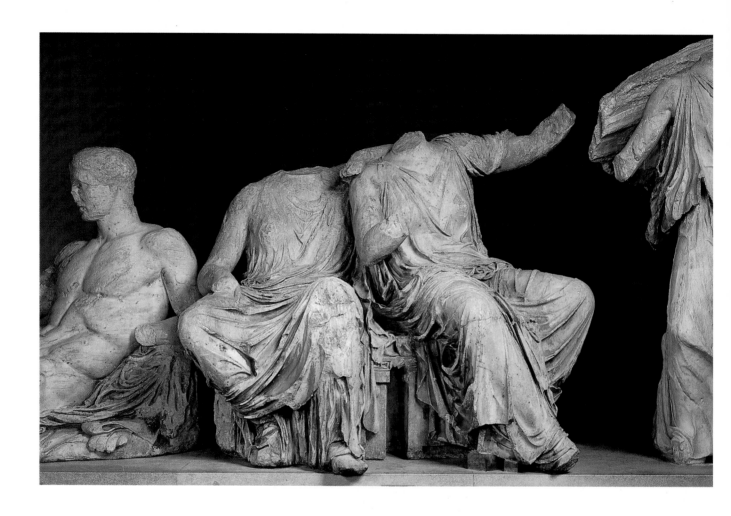

61 Two heavily draped female figures seated on rectangular chests, perhaps Demeter and her daughter Persephone. East pediment E and F.

accomplished technique as well as a rather unusual style that ignores finicky detail in its concentration on sweeping folds and broad gestures. The statue includes a plinth, now inset into the pedestal as formerly into the floor of the pediment. The angle at which the figure is set is, therefore, assured: she seems to be about to stride out of the pediment, breaking the front plane of the composition. This can only be part of a deliberate attempt by the designer to give a three-dimensional quality to the whole scene, an attempt seen also in the pro-

jection beyond the edge of the cornice of horses' heads, the left leg of the reclining male and the differing angles of the chests on which his neighbours sit.

The seated and reclining figures on the left side of the pediment are subtly balanced by three that survive on the right. Here, however, all three are female and it is the outer rather than the inner pair that was carved from a single block of marble. Their old identification as the Three Fates cannot be right, but again scholars are not unanimous on whom they represent. There must

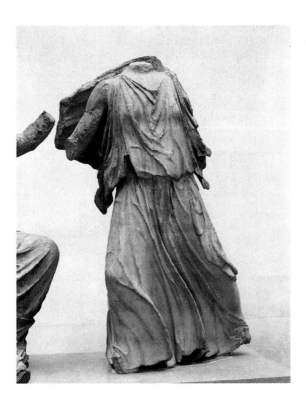

62 *right* Unidentified female figure, perhaps Hebe, rushing towards the left. East pediment G.

63 *below* One of the horses from the chariot of Selene (the Moon) sinking into the waters of Okeanos, exhausted by its journey across the heavens. East pediment O.

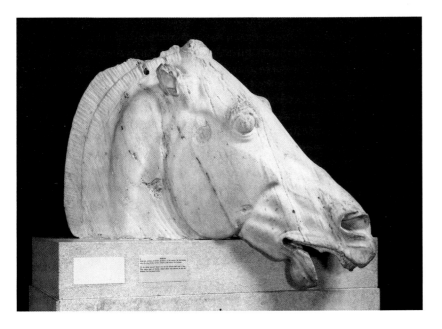

be a close relationship between the outer pair, one reclining in the lap of the other, 65 and many believe that the languorous pose of the reclining figure and her voluptuous drapery, slipping off her right shoulder and all but baring her breast, can only belong to Aphrodite. If this is correct, the most likely person to cradle her is her mother, Dione. Others prefer to interpret these figures not as goddesses but as personifications of the Sea (Thalassa) in the lap of Earth (Gaia). The separate seated figure is usually thought to 64 be Hestia, the goddess of the hearth. The contrast between the crinkly surface of her *chiton* and the deeply undercut folds of the heavier garment around her knees recalls the drapery of the seated figures on the other side. These are all staid and sober persons, quite different, it seems, in character from the indolent figure reclining on the right. Here, with a brilliance of conception and execution unsurpassed on the Parthenon, the sculptor has shown that drapery can be full of fine detail without being fussy, can cover the body without concealing its form, and can even suggest the character of the subject and her state of mind.

At the extreme right of the composition as on the left, the floor of the pediment is dissolved, and into the waters of Okeanos sinks the chariot of Selene (the Moon), or perhaps of Nyx (Night). The charioteer's torso (now in the Acropolis Museum) had been knocked down by a broken cornice-block before the Carrey drawing and was not found until 1840. Three of the horses' heads, badly damaged, were left in place, but the fourth is perhaps the best loved of 63 all the Elgin Marbles. The horses of Helios are full of energy, tossing their heads in their eagerness to be off across the sky. This horse has run his course: his drooping jaw and flaring nostril express his utter weariness.

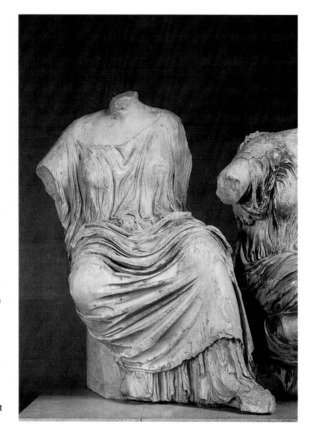

64 *right* Seated female figure, perhaps Hestia. She wears an ankle-length tunic of fine, crinkly material beneath an outer garment of heavier stuff. East pediment K.

65 *below* Two female figures, perhaps Aphrodite reclining in the lap of her mother, Dione. The difference in posture enables the group to fit in the diminishing space below the raking cornice. East pediment L and M.

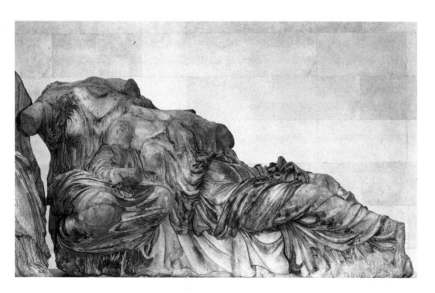

The horse's head hung over the edge of the horizontal cornice and a cutting was made in the left side of the jaw to fit around the moulding on the face of the block. Another rough cutting was made in the top of the head so that it would fit beneath the projecting edge of the raking cornice. Other sculptures suffered in the same way: a large hollow was hacked at the back of Hestia to accommodate the neighbouring block. These cuttings must have been made by the stonemasons who set the sculptures in place: the sculptors who carved them must have been horrified. There was evidently some minor miscalculation in translating the initial design of the pediment into marble.

Pedimental groups were never easy to design, and the extra width of the Parthenon, with a corresponding increase in height at the centre, added to the problems. We know from the drawings that the design 46 of the west pediment was a triumphant 47 success, with figures and groups on either side balancing but not repeating each other, and with the problem of height solved by a subtly graded change of scale. These features must have been present too in the east, but here there are two new elements: a more open, three-dimensional composition that seems to spill over from the pediment's shallow field; and an unprecedented solution to the problem of filling the outer angles. Helios and Selene, who define the time of day, the dawn, also frame the composition just as they did the scene on the pedestal of the statue of Zeus at Olympia, the masterpiece of Pheidias. Their presence in the east pediment suggests that here too Pheidias had a hand, at least in the design.

4 Lord Elgin and his Collection

Lord Elgin's Embassy

By the end of the eighteenth century the Parthenon and the other buildings on the Acropolis were in a perilous condition, but their fate was changed utterly after the appointment of the Earl of Elgin as Ambassador Extraordinary and Minister Plenipotentiary of His Britannic Majesty to the Sublime Porte of Selim III, Sultan of Turkey. Thomas Bruce, seventh Earl of Elgin and eleventh Earl of Kincardine, was born on 20 July 1766 and succeeded to the title in 1771 when he was not quite five years old. After his education at Harrow and Westminster, St Andrews and Paris, he began to make his way in public life. He began his military career as an Ensign in the Foot Guards, and later raised and commanded his own regiment. In 1790, aged twenty-four, he had been elected as one of the sixteen representative peers for Scotland and was to keep his seat in the House of Lords for seventeen years. His diplomatic career began in 1791 when he was sent to Vienna as Envoy Extraordinary to treat with the new Emperor, Leopold II. This was followed by two years in Brussels from 1792 and three years in Berlin. By the age of thirty-two he had made his mark in the three professions open to a British nobleman: the army, politics and diplomacy. He seemed set on a brilliant public career, particularly on his appointment as Ambassador at Constantinople.

In March 1799 he married Mary Nisbet of Dirleton, who was not only a great beauty but also heiress to a fortune reputed to be worth some £18,000 a year. This must have made her doubly attractive to Elgin, who was already financially embarrassed by his diplomatic expenses and the cost of his new house at Broomhall. Begun in 1796, Broomhall was the work of the Neo-classical architect Thomas Harrison, and it was Harrison who first suggested to Elgin that

his term of office in Constantinople would provide an opportunity to improve the knowledge of architecture in Great Britain. The best examples of classical architecture were in Athens rather than in Rome, where architects had previously been accustomed to study. Harrison fired Elgin with enthusiasm for the project, which would require not only drawings but plaster casts to provide a three-dimensional supplement to the published engravings. Elgin's aim was always henceforth that his embassy should be 'beneficial to the progress of the Fine Arts in Great Britain', but there was at this initial stage no suggestion of removing original examples of architecture or sculpture.

At first Elgin attempted to obtain financial support from the Government for this proposal, but when Whitehall showed no enthusiasm he determined to go ahead at his own expense. He interviewed various artists including J.M.W. Turner, but being unable to reach an agreement with any of them on salary and terms of service he decided to postpone the recruitment of artists. He did, however, appoint William Richard Hamilton as his first Private Secretary and the Revd Philip Hunt as his Chaplain.

On their long journey to Constantinople the Elgins stopped at various ports including Palermo, where they met the British Ambassador, Sir William Hamilton, together with his wife Emma and Lord Nelson. (Sir William Hamilton, British Minister to the Kingdom of the Two Sicilies from 1764 to 1800, must not be confused with Elgin's secretary, William Richard Hamilton, who was to hold the same post from 1822 to 1825.) On Sir William's recommendation Elgin engaged the landscape-painter Giovanni Battista Lusieri to draw in Athens for £200 a year and his keep. Lusieri

66 Beetle (scarab) of Egyptian granite, originally from Egypt but probably acquired by Elgin in Constantinople. British Museum, EA 74.

two marbles: a sculptured base and an inscribed stele that served as a bench. Since the inscription, in the archaic Attic and Ionic alphabets and dialects, was unintelligible to the villagers, they credited it with miraculous powers and used to roll the sick on it in hope of a cure. In consequence the lettering, fully visible some years before, was being worn away and is now fully legible only with the aid of earlier notes. With the approval of the local authorities Elgin acquired both pieces: the first of the Elgin Marbles were thus acquired on the Turkish mainland. In Constantinople Elgin also acquired a colossal granite scarab, 66 which must have come originally from Egypt.

In Athens Elgin's artists depended greatly on the support of the British Consul, Logotheti. Athens in those days was a small and rather squalid town, and the party's difficulties were aggravated by the obstruction of the local Turkish authorities, especially the Disdar (military commandant of the Acropolis). Logotheti wrote constantly to Elgin asking him to obtain a letter from the Turkish Government instructing the authorities in Athens to allow the artists and moulders access to the buildings of the Acropolis. Although the Acropolis was still a Turkish fortress, by February 1801 Logotheti arranged permission for the architects to draw there, at a fee of 5 guineas a day. The Turks, however, still refused to allow the erection of scaffolding for the moulders, perhaps fearing that the gardens of their harems might be overlooked. The moulders, therefore, began their work on the Hephaisteion and the Monument of Lysicrates in the lower town.

Turkish obstruction of foreigners in Athens was nothing new. A French citizen, Louis-François-Sébastien Fauvel, had been

and W.R. Hamilton were then sent to Naples and Rome to recruit the other artists required for the project. As figure-painter they chose Feodor Ivanovitch, a Tartar who had been enslaved as a child and subsequently presented by a member of the Royal court at St Petersburg to a German relation. At Baden his artistic talents were recognised, and after training in Rome he had acquired a considerable reputation. He came to be known as 'Lord Elgin's Calmuck'. Elgin had wanted a man to make casts but Hamilton found it necessary to engage two, Bernadino Ledus and Vincenzo Rosati. He also engaged two architectural draughtsmen, Vincenzo Balestra and a young student, Sebastian Ittar. After some delays this team arrived in Constantinople in May 1800 and reached Athens in August.

Meanwhile Elgin and his party had themselves arrived in Constantinople, having landed first at the Dardanelles. Outside the church in a nearby village were

resident in Athens since 1783 as the full-time agent of the French Ambassador in Constantinople, the Comte de Choiseul-Gouffier. One of Choiseul-Gouffier's aims was the same as Elgin's: to obtain casts and drawings, and he had obtained a firman for Fauvel to do this. Fauvel was also instructed to collect antiquities: 'Take away everything you can. Do not neglect any opportunity to remove everything in Athens and its neighbourhood that is removable.' He had acquired a number of antiquities but the Turks persisted in their refusal to allow him to take any sculptures from the Parthenon. He did, however, manage to obtain by bribery a splendidly preserved slab of the east frieze as well as a metope, which were dug up in the ruins. These eventually found their way to the Louvre, but Fauvel was long unable to export a metope that fell during a storm in 77 1788.

Early in 1801 Lusieri returned to Constantinople to report to Elgin and to confirm the need for a firman, a document from the Turkish Government authorising their operations. This Elgin obtained and dispatched to Athens, but it seems to have gone astray. On 16 May Lusieri, now back in Athens, wrote to Elgin that the architects had completed their work on the Acropolis but the moulders and Feodor had not yet been able to begin, for the promised firman had not yet arrived and a new one was needed. On the same day Logotheti wrote to report that the Disdar had closed the Acropolis since the Government, on hearing the news that the French fleet was gathering at Toulon, had ordered all military installations to be closed to foreigners. Turkish alarm was justified: the French fleet was bound for Egypt.

Meanwhile, Lady Elgin's parents, the Nisbets, had arrived in Athens and together with Philip Hunt had visited the Acropolis under Lusieri's guidance. Hunt wrote to Elgin on 22 May that a firman was essential if the metopes and frieze were to be drawn and moulded. Further encouraged by a letter from the Nisbets, Elgin began negotiating for a new firman on 14 June. Hunt was now back in Constantinople. He had seen in Athens the rate at which antiquities were being destroyed, and he therefore urged on Elgin a radical change in plan. In a memorandum dated 1 July 1801 he recommended that authority for the artists to work in Athens should be sought under three heads:

(1) to enter freely within the walls of the Citadel, and to draw and model with plaster the Ancient Temples there.
(2) to erect scaffolding and to dig where they may wish to discover the ancient foundations.
(3) liberty to take away any sculpture or inscriptions which do not interfere with the works or walls of the Citadel.

The third item was a new departure, not envisaged when Elgin first accepted Harrison's advice to secure casts and drawings. Elgin however seems to have required little persuasion and made his request accordingly. From the Turkish point of view, the request could hardly have come at a more opportune time. On 17 June the French army in Egypt had capitulated to the British, so that the Turkish Government was predisposed to be accommodating to the British Ambassador. On 6 July Elgin received the desired firman and two days later Hunt left Constantinople with it, arriving in Athens on 22 July. The firman was addressed to the Voivode (civil governor) and Cadi (chief justice) in Athens and was quite sweeping in its terms. The Turkish original has not survived, but the following extract is translated from a contemporary Italian version:

It is our desire that on the arrival of this letter you

use your diligence to act conformably to the instances of the said Ambassador, as long as the said five Artists dwelling at Athens shall be employed in going in and out of the said citadel of Athens, which is the place of their occupations; or in fixing scaffolding around the ancient Temple of the Idols, or in modelling with chalk or gypsum the said ornaments and visible figures thereon; or in measuring the fragments and vestiges of other ruined edifices; or in excavating, when they find it necessary, the foundations, in search of inscriptions among the rubbish; that they be not molested by the said Disdar, nor by any other persons, nor even by you; and that no one meddle with their scaffolding or implements, nor hinder them from taking away any pieces of stone with inscriptions or figures

On 23 July Hunt delivered the firman to the Voivode. The situation was transformed virtually overnight: the artists and moulders were now able to work on the Acropolis without hindrance. Without doubt the most valuable accomplishment of the moulders was to make casts of those slabs of the west frieze of the Parthenon that are still in place on the temple, for they have deteriorated still further in the period of almost two centuries that has since elapsed. The drawings of Feodor the Calmuck are archaeologically less valuable, for he drew not only what he saw but what he imagined had been lost. When he drew slab XIV of the ₆₈ west frieze, a fragment comprising the torso and head of a youth was already missing from it. The missing fragment was ₆₇ presented to the British Musuem in 1840 by J.J. Dubois, and shows clearly that the youth's *chlamys* was fastened around his neck as Feodor had failed to understand.

While Feodor and the moulders carried on their work, Lusieri, encouraged by a letter from Elgin, tackled with enthusiasm the task of collecting 'pieces of stone with

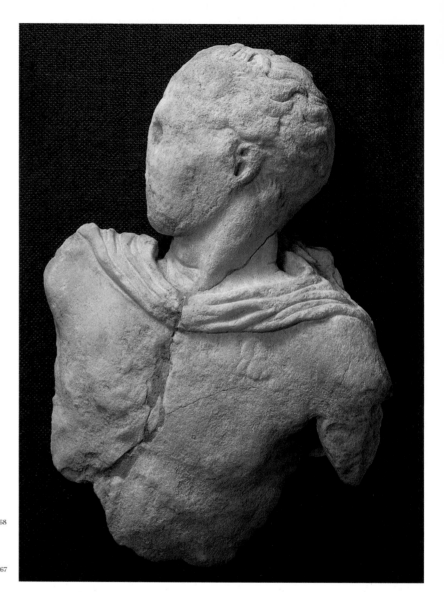

67 *above* Fragment removed from the west frieze of the Parthenon before Elgin's party arrived. Presented to the British Museum in 1840 by J.J. Dubois. G R 1840. 11-11.5.

68 *opposite, top left* Drawing by Feodor Ivanovitch of slab XIV of the west frieze of the Parthenon. The head and upper torso of the figure on the right were already missing, but Feodor drew them in as if they were still there. He failed to realise that the young man's chlamys was fastened around his neck: see illustration above.

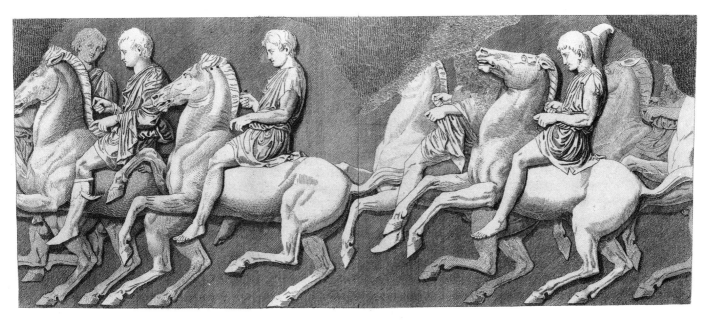

69 *above* Slabs XXV and XXVI of the north frieze of the Parthenon as engraved after an earlier drawing by James Stuart for volume II of *Antiquities of Athens*, published in 1787. Most of slab XXVI survives, but only a fragment of slab XXV remained when Elgin's party arrived in Athens: see fig. 70.

70 *top right* The surviving fragment of north frieze slab XXV. The condition of the slab about 1755 can be seen in Stuart's engraving above.

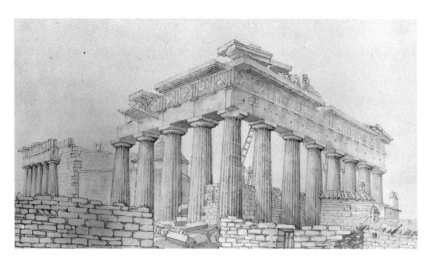

71 The Parthenon in July 1801, with tackle in place for the removal of a metope. Drawing by Sir William Gell. *British Museum Catalogue of Drawings by British Artists*, Gell 13 (76).

inscriptions or figures'. A force of workmen was employed to collect inscriptions from the Acropolis and to clear debris from the Caryatid porch of the Erechtheion. Then Hunt asked for, and after some hesitation received, permission to remove a metope from the Parthenon itself. This was the crucial moment, and it may be questioned whether the firman actually authorised even the partial dismantling of buildings in order to remove sculptures. Hunt's request carried the day. When questioned in 1816 by the Select Committee Hunt agreed that the Voivode had been induced 'to extend rather than contract the precise permissions of the firman'. He was undoubtedly motivated by the risk to the Parthenon sculptures that was evident from recent damage. Eight of the pedimental figures drawn by Dalton in 1749 had meanwhile disappeared. Several slabs of the frieze drawn by Stuart in the early 1750s were 69 wholly or partly lost, and other frieze-blocks 70 moulded by Fauvel in the 1790s had been broken or defaced.

The first metope was taken down from the Parthenon on 31 July, and by the 71 following June more than half of the

Parthenon sculptures that were eventually to form part of the Elgin Collection had already followed it. Some of the sculptures had fallen from the Parthenon in the aftermath of the explosion and were found either buried in the ground or built into later structures, but many were removed from the building itself. Excavations were not always successful. On one occasion a house near the Parthenon was purchased and demolished. The site was excavated to the bedrock, but no sculptures were found. The former owner (a Turk) laughed, saying that he had burnt the pieces of statues found on the spot to make lime for the mortar to build the house.

The work of collecting was to continue until 1804, and for most of that time Lusieri was left to his own devices. As a result of the war between France and Turkey, Fauvel had been in prison in Athens since 1800. In 1801 he was sent to Constantinople and was unable to return until 1803. He was thus out of the way when the firman arrived, enabling Lusieri to accomplish what he had himself striven to do for nearly twenty years. All French property was in theory sequestrated, but the Turks handed over to Lusieri Fauvel's tackle and a cart, the only one in Athens strong enough to take the heavy marbles. It is very doubtful whether Lusieri would have been so successful in fulfilling Elgin's wishes without the equipment provided for Fauvel by Choiseul-Gouffier.

Elgin himself visited Greece for the first time between 1 April and 15 June 1802, and even before he arrived many of the sculptures were already crated and on their way to England. The first two metopes had been consigned to Egypt in a Ragusan merchantman, *Constanza*, and Elgin's own brig *Mentor* had taken a consignment of ten crates of marbles and moulds as far as

72 The Lion Gate at Mycenae about 1802, drawn by Sebastian Ittar, a draughtsman employed by Elgin. British Museum, Department of Greek and Roman Antiquities.

PORTA PRINCIPALE

Alexandria. Other crates were shipped aboard the naval vessels HMS *La Diane* and HMS *Mutine*, the commander of the latter being cajoled by Lady Elgin herself to embark more than he had originally intended. While in Greece the Elgins undertook journeys around the country, in particular to the Argolid and Thebes. In Mycenae debris was cleared from the 'Treasury of Atreus' and some fragmentary reliefs of gypsum and coloured marble were removed. Hunt even considered the possibility of removing the Lion Gate but baulked 72 at the difficulty.

On his return to Constantinople Elgin obtained documents from the Turkish Government approving all that the Voivode and the Disdar had done in Athens to assist Lusieri's work on behalf of Elgin. Lusieri seems to have handed them over to the two officials and no copies have survived. Had they done so, they would no doubt support Elgin's claim that everything he did had been approved by the Turkish authorities.

Early in May Lusieri collected four frieze-blocks of the Temple of Athena-Nike, which had been dismantled and incorporated in the fortifications. Together with some slabs of the Parthenon frieze and a marble throne that the Archbishop of Athens had presented to the Nisbets, these were loaded on *Mentor* for a second trip to Alexandria on 15 September. It was *Mentor*'s last voyage, for she sank in 12 fathoms at the entrance to the harbour of Cerigo (modern Cythera). All seventeen crates aboard were eventually recovered, but the work continued until October 1804 and cost Elgin some £5,000.

Lusieri continued to report further acquisitions during 1802 and 1803, including an eighth metope in September 1802 and a ninth in October, when he added a pledge to remain in Athens to complete his drawings 'so that some of the barbarisms I have been obliged to commit in your service may be forgotten.' He seems to have been referring to the removal of cornice-blocks from the south side of the Parthenon in order to extract the metopes.

It was probably in 1802 that the collection of specimens of architecture led to the removal of a Doric capital, an Ionic column-drum and a moulded wall-block from the Propylaea, which had been in ruins since 73 the explosion of 1645 and was choked with debris. The statue of Dionysos from the Monument of Thrasyllos on the south slope of the Acropolis must have been collected about the same time, but it was perhaps not until 1803 that a Caryatid was removed from 3, back the south porch of the Erechtheion, from *cover* which a column and an architrave-block from the east porch and other architectural members were also taken at some stage.

In January 1803 Elgin left Constantinople on the conclusion of his embassy. After

spending some days in Athens he took the other artists with him but left Lusieri behind to continue the work of collecting sculptures and packing them for shipment. In May 1804 Lusieri had to suspend his activities on the Acropolis but continued to excavate elsewhere until October 1805, when the Voivode banned all excavation. By this time most of the sculptures had reached England, but Elgin had not.

Elgin spent Easter of 1803 in Rome, where he invited Canova to undertake the restoration of the sculptures. Restoration of missing parts of ancient sculpture was still the standard practice, and Elgin was right to seek a sculptor of the highest rank. Canova helped to change the fashion, admitting, with the humility of a great artist, that 'it would be a sacrilege in him or any man to presume to touch them with a chisel.' From Rome Elgin continued his journey home overland, and he was unfortunately in France when war was declared against England on 18 May 1803. Elgin was arrested and remained in France as a prisoner of war until his release on parole in 1806.

There were still some forty cases of antiquities awaiting shipment from Piraeus, including vases and coins as well as sculptures. Lusieri's supply of funds had been cut off for some time and he was desperate when Elgin's release relieved him. Before long, however, Britain was at war with Turkey and Lusieri had to flee to Athens, leaving the crates behind. In his absence some items were seized by Fauvel, but the sculptures were still there when peace between Britain and Turkey in 1809 allowed Lusieri to return and to secure a firman to ship the crates. This firman to remove the marbles must imply that any irregularities that may have occurred in interpreting the powers granted by the

73 *left* The western end of the Acropolis seen from the pediment of the Parthenon about 1801. The Propylaea was then incorporated in the defences and the columns of the inner porch can be seen emerging from the deep accumulation of debris. Drawing by Sir William Gell. *British Museum Catalogue of Drawings by British Artists,* Gell 13 (80).

74 *left, below* The Erechtheion from the west about 1801. The man with a parasol is thought to be Lusieri. Drawing by Sir William Gell. *British Museum Catalogue of Drawings by British Artists,* Gell 13 (61).

75 *right* The Propylaea from the east. After Greek Independence part of the entablature of the inner porch was restored.

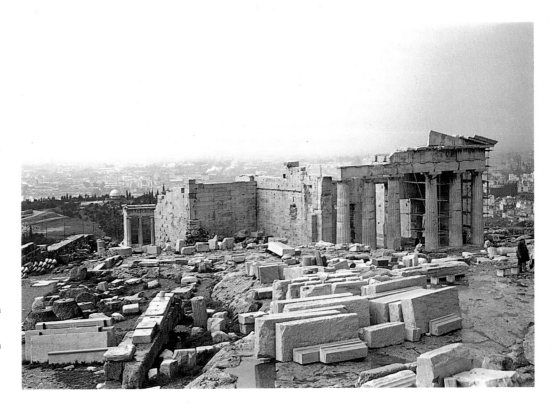

previous document were at least condoned if not fully approved.

By 1810 all but five crates had gone, and on 22 April 1811 the last boxes left Athens on board *Hydra* accompanied not only by Lusieri but by Lord Byron. Lusieri later returned to Athens and died there in 1821 at the age of seventy, the drawings for which he had originally been recruited still unfinished.

The Elgin Marbles reach London

The crates that reached London while Elgin was still a prisoner of war were stored unopened, first at the Duchess of Portland's house and later at the Duke of Richmond's. After his release, Elgin took a house at the corner of Park Lane and Piccadilly and had a large shed built in the grounds to accom- 76 modate the marbles, which were augmented by several consignments that still lay at various ports. They included several boxes that had been left at the Customs House in London having been captured on board a French frigate *L'Arabe* in 1803 and sent to England on Nelson's orders in case the Government wished to buy them from the crew, to whom they belonged by the law of prize. The boxes had been collected by *L'Arabe* from Piraeus on the express command of Napoleon, for they contained antiquities acquired by Fauvel for Choiseul-Gouffier, including the metope that had 77 fallen off the Parthenon in a storm. Finding these boxes at the Customs House, Elgin's

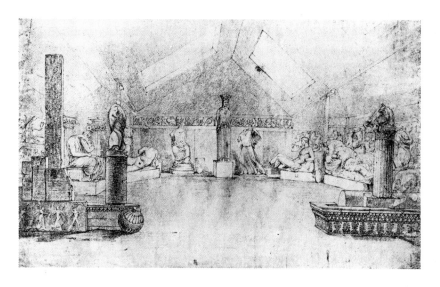

agents bought them, thinking them to be his, so that the metope finally joined the Elgin Collection. Many of the sculptures he now saw himself for the first time, and from the summer of 1807 permission was given for selected visitors to view them. Among the visitors were the actress Mrs Siddons, said to have been moved to tears by the pedimental figures then known as the Three Fates, and Richard Payne Knight, connoisseur, collector and member of the Society of Dilettanti. Knight was to become a most generous benefactor of the British Museum, but he is chiefly remembered for his disparagement of the Elgin Marbles: 'You have lost your labour, my Lord Elgin. Your marbles are overrated: they are not Greek: they are Roman of the time of Hadrian.' Although he persisted in this mistaken view, it should be remembered that he also noted the discrepancies in the quality of the metopes and suggested that they were by different hands.

Other visitors included the artists Flaxman, Wilkie, Haydon, Fuseli, West and Lawrence. All were impressed. John Flaxman, a pupil of Canova in the Neo-classical style of sculpture, declared the marbles 'very far superior' to the Roman copies of Greek works in museums and private collections that had until then been the touchstone of correct taste. Benjamin West spent hours sketching the marbles and wrote to Elgin, praising him warmly for

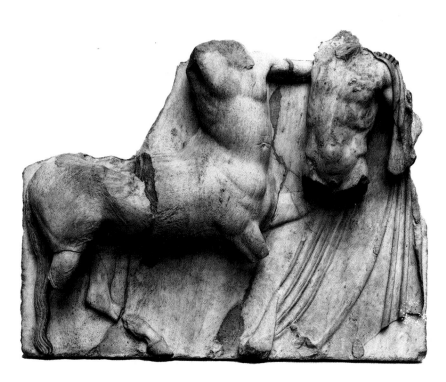

76 *above left* The Elgin Marbles in the shed at Park Lane, 1810. The sculptures were symmetrically arranged without regard to their subject or original positions. Drawing by C.R. Cockerell belonging to the Earl of Elgin.

77 *left* Metope showing a centaur and a young man, originally acquired by Fauvel for Choiseul-Gouffier. The figured part broke into three pieces when it fell from the Parthenon during a storm. The upper part was not preserved and has been restored in plaster. South metope VI.

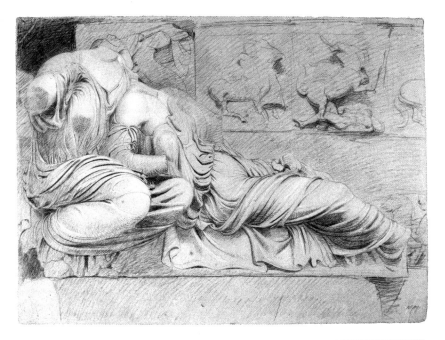

bringing them to London. Benjamin Robert Haydon was especially enthusiastic: 'I felt as if a divine truth had blazed inwardly upon my mind, and I knew that they would at last rouse the art of Europe from its slumber of darkness.' [78] [79]

Flaxman was even invited to restore the marbles, but when he pointed out that restoration could hardly increase their value and would cost about £20,000, Elgin at last abandoned the idea. Elgin was now in deep financial difficulties. Diplomatic and other expenses in Turkey had heavily outstripped his official allowances, his own income was barely £2,000 a year, and he had lost access to the Nisbet fortune when he found it necessary to divorce his wife. In addition the acquisition, transport and care of the marbles had cost him over £39,000. He had long abandoned the idea of taking the marbles to Broomhall, and in 1810 began to consider selling them to the Government.

Encouraged by the virtually universal admiration that the marbles had received and by overtures from the British Museum about his intentions, Elgin discussed the possibility of a sale with Joseph Planta, Principal Librarian of the Museum, and the Speaker of the House of Commons, who was one of the Principal Trustees, *ex officio*. After a year of informal negotiation, Elgin wrote to the Paymaster-General in May 1811 offering his collection to the nation for £62,440, a sum comprising his actual expenses and fourteen years' interest. The

78 *above left* Two of the 'Three Fates' from the east pediment of the Parthenon, drawn by Benjamin Robert Haydon in 1806. *British Museum Catalogue of Drawings by British Artists*, Haydon 3 (6).

79 *left* Studies by Benjamin Robert Haydon in 1809 of the horse of Selene from the east pediment of the Parthenon. *British Museum Catalogue of Drawings by British Artists*, Haydon 3 (2).

80 Part of the procession on the north frieze of the Parthenon in a reduced version, with many details restored, by John Henning. Slate mould for the production of plaster casts (reversed in the illustration). British Museum GR 1938. 11-18. 27.

reply was bitterly disappointing to Elgin: the Government were only prepared to recommend Parliament to purchase the collection for £30,000.

Meanwhile Elgin's financial difficulties had made it prudent to sell the house in Park Lane, and a new home was needed for the marbles. When the Duke of Devonshire agreed to provide temporary accommodation at Burlington House, the marbles were moved to a shed in the yard there. The move began in July 1811 and cost Elgin a further £1,500. In the following year the collection was augmented by the arrival of the last crates from Malta. The entire collection was now stored in crowded and rather poor conditions, but artists like Nollekens, West, Flaxman and Haydon continued to draw them. They were also drawn by a Scottish sculptor, John Henning, who went on to produce both a 80 small-scale restoration of the frieze in the form of slate moulds, from which sets of plaster casts were sold, and full-scale copies for the Hyde Park Corner Arch, the Athenaeum, the Royal College of Surgeons and elsewhere. His moulds are now in the British Museum.

Peace with France in 1814 allowed Elgin to invite Ennio Visconti to see the marbles. Visconti, the most celebrated archaeologist of the day, was then Director of the Louvre, having gone there with the marbles removed from the Capitoline Museum in Rome by Napoleon, who had also pillaged the Vatican to provide masterpieces for Paris. Visconti was most enthusiastic, and later wrote a laudatory memoir, which Elgin planned to use as ammunition in his campaign to persuade the Government to buy the collection.

In March 1815 Elgin was dismayed to learn that Burlington House had been sold and was to be rebuilt. A decision on the future of the marbles was now urgent. Elgin, therefore, reopened the question with the British Museum but was disappointed when the Trustees appointed Richard Payne Knight and his disciple Lord Aberdeen to the committee to conduct negotiations. Having discussed the matter with Hamilton, now an Under Secretary at the Foreign Office, Elgin wrote to the Chancellor of the Exchequer on 8 June suggesting that negotiations between himself, the Museum and the Government should be abandoned. Instead the question should be referred to a Select Committee of the House of Commons, who could investigate the circumstances under which he had collected the marbles and recommend whether and at what price they should be

acquired for the nation.

The Chancellor welcomed the proposal of a Select Committee and suggested that Elgin should present the case to Parliament. *The Petition of the Earl of Elgin Respecting his Collection of Marbles* was submitted to the House of Commons on 15 June 1815, but, following news of the defeat of Napoleon at Waterloo, the action on the marbles was postponed to the following year. Meanwhile the art treasures looted by Napoleon were removed from the Louvre, including the Apollo Belvedere, the Torso Belvedere and the Laocoon, which were returned to the Vatican. Visconti's memoir on the Elgin Marbles was published in August, forming the basis for a new catalogue of the collection; and Canova came to London in November to see the marbles for the first time. Visconti's memoir was paid for by Elgin, but Canova's praise was disinterested: 'Oh, that I had but to begin again! to unlearn all that I had learned – I now at last see what ought to form the real school of sculpture.'

Elgin also offered to return to Choiseul-Gouffier the metope that had been captured by Nelson. Owing to his misunderstanding of the system of disposing of naval prizes, Choiseul-Gouffier at first thought that all his sculptures were still in Malta and later accused Elgin's agents of having stolen them. So the question of the metope remained unresolved.

In February 1816 a second petition was presented to the new session of Parliament, in the same terms as before but now having the backing of the Prince Regent. It was debated on 23 February and a Select Committee was appointed to consider it. The Committee's report was ready by 25 March and was subsequently printed by order of the House of Commons. It remains an invaluable source of information, because it includes not only the Committee's recommendations but the evidence on which they were based: the questions put to witnesses and their replies. Elgin himself was the first witness and was asked in detail about the acquisition of the collection and its cost. He supported his answers with various documents and produced detailed accounts of his expenditure, showing that the marbles had cost him £74,240, including interest. Elgin distinguished between the value of the collection and the expenses he had incurred, stating that the latter were submitted

to prove, that in amassing these remains of antiquity for the benefit of my Country, and in rescuing them from the imminent and unavoidable destruction with which they were threatened, had they been left many years longer the prey of mischievous Turks, who mutilated them for wanton amusement, or for the purpose of selling them piecemeal to occasional travellers; I have been actuated by no motives of private emolument; nor deterred from doing what I felt to be a substantial good, by considerations of personal risk, or the fear of calumnious misrepresentations.

Hamilton was also interviewed and confirmed Elgin's account of the acquisition, adding an appraisal of the collection at £60,000.

Among the artists examined were the sculptors Nollekens, Flaxman, Westmacott, Chantrey and Rossi, the painters Lawrence and West, and the architect Wilkins. Elgin wished to have Haydon called but he was passed over for fear of offending Payne Knight, with whom he had quarrelled in the newspapers on the importance of the marbles. The questions they were asked betray the taste of the times: in what class of art did the marbles belong? Were they as good as acknowledged masterpieces like the Apollo and Torso Belvedere and the

Laocoon? Did they have more 'Ideal Beauty'? Did their unrestored state detract from their value? These were questions from men trained in the eighteenth century to appreciate smoothly restored Graeco-Roman sculptures. The arrival of the Parthenon sculptures in London made questions like these out of date, and the answers of the artists showed that they, like Canova, had already realised this. The Elgin Marbles were 'the finest things that ever came to this country' (Nollekens); 'the finest works of art I have ever seen' (Flaxman); 'infinitely superior to the Apollo Belvedere' (Westmacott). Payne Knight, of course, disagreed. He was the representative of the old standards of taste and was in addition hostile to Elgin. The Committee wisely disregarded his claim, repeated from the seventeenth-century French traveller Spon, that some of the pedimental sculptures were Hadrianic replacements, for he had to admit that there was no evidence for the assertion. His valuation of the entire collection at £25,000 was absurd, including such topsy-turvy individual valuations as £200 for the horse-head from the east pediment and £300 for the Egyptian scarab! Lord Aberdeen valued the collection at £35,000.

Apart from the valuation of the marbles the Select Committee's report vindicated all Elgin's claims. It found that the collection had been formed with the approval of the Turkish authorities, and that, although Elgin had been serving as Ambassador, he had acted in a private capacity in collecting. The Committee concurred in the opinions of the artists who had rated the marbles 'in the very first class of ancient art, some placing them a little above, and others but very little below' the Apollo and Torso Belvedere and the Laocoon. On the value, however, the Committee settled on Lord 81 Aberdeen's estimate of £35,000. Elgin, of course, was deeply disappointed and commented on the Report's 'manifest coldness and ill-will'. But he could do no more: his financial difficulties were such that he had to accept even this figure. The Report was debated by the House of Commons on 7 June 1816 and adopted by eighty-two votes to thirty. An Act of Parliament was eventually passed to transfer ownership of the Elgin Marbles to the nation and they were transferred to the British Museum. The metope that Fauvel had acquired for Choiseul-Gouffier in 1788 was 'deposited in this collection until M. de Choiseul shall cause it to be removed'. He failed to do so before his death in 1817 and the metope was incorporated in the collection in 1818.

The Marbles in the British Museum

The marbles were transferred from Burlington House to the British Museum in 1816, and a temporary gallery constructed in the previous year for the Bassae frieze was extended to receive them. The 'Temporary Elgin Room' was opened to the public in 1817 and remained in use for fourteen years. Its structure forms the setting for a painting by A. Archer, in which 82 the arrangement of the pedimental sculptures is not entirely true to life. The metopes, however, are shown correctly, set into the walls high above the frieze-blocks. This method of exhibiting the metopes was to be followed until 1939. In 1835 the entire collection of marbles was exhibited in a newly constructed permanent gallery, 'The Elgin Saloon', which continued to house the main body of Parthenon sculpture until 1961 (it is now Room 7, the Nereid Room). Between 1857 and 1869 the pediments were shown separately in a newly built gallery to the south (now Room 5, the 'Room of the Harpy Tomb'), but from 1869 to 1939 the

81 The Royal Academy by Henry Singleton (1766-1839). The casts include the Apollo Belvedere, the Laocoon and the Torso Belvedere. British Museum PD 1936-1-3-27.

82 The Temporary Elgin Room in 1819. Oil-painting by A. Archer, shown seated in the right foreground. Also seated are Sir Benjamin West, PRA, and Joseph Planta (Principal Librarian). In the extreme left is Benjamin Robert Haydon. British Museum.

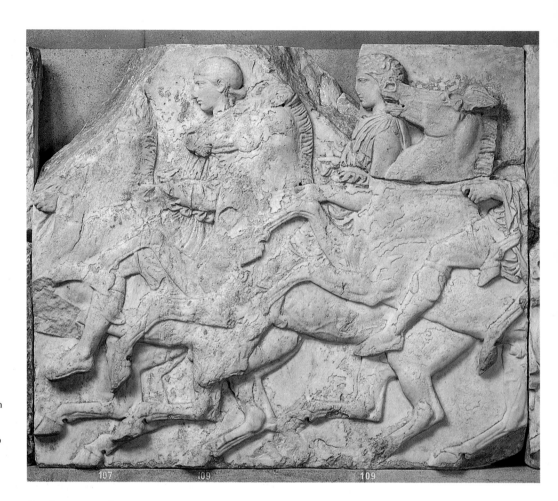

83 Riders on the Parthenon frieze. The fragment on the upper right was presented by the Society of Dilettanti to join the rest of the slabs in the Elgin collection. North frieze slab XXXV.

Parthenon sculptures were exhibited in the Elgin Room, while many of the other marbles in the Elgin Collection were withdrawn for exhibition elsewhere.

Between 1869 and 1939 the exhibition remained substantially unchanged (apart from the removal of the pedimental figures to the greater safety of the basement between 1915 and 1919). Its guiding principle was to present the sculptures of the Parthenon in as complete a form as possible. The sculptures acquired by Lord Elgin had been augmented from time to time by fragments removed piecemeal by earlier travellers. A fragment of the north frieze, previously owned by the Society of Dilettanti, was presented by the Royal Academy in 1817, and the Society of Dilettanti itself added a second fragment, 83 perhaps brought to England by W. Chandler around 1765. Fragments presented by J.J. Dubois in 1840 included the right hindleg of the centaur on south metope II and a fragment from slab XIV of the west frieze. 67 Other frieze fragments were presented by J. Smith Barry of Marbury Hall and by C.R. Cockerell. In 1859 the Duke of Devonshire presented a head that joins a body in the

Elgin Collection. Comparison with the Carrey drawing suggests that they belong to south metope XVI, which was shattered by the explosion. In 1865 the Museum bought from the Pourtalès Collection a fragment of the north frieze that had once belonged to Fauvel. In 1919 J.J. Dumville-Botterell presented another substantial fragment of the north frieze formerly at Colne Park. In addition to these fragments, the marbles were supplemented by a large series of plaster casts of pieces in Athens, Paris, Copenhagen and elsewhere. Although this arrangement was very useful to scholars, the mixture of originals and plaster casts was aesthetically unattractive and also tended to confuse the ordinary visitor. The addition of models, photographs, drawings and diagrams in the limited space available added to the congestion, so that some parts of the display obstructed the view of others.

Following public expression of these criticisms in 1928, in a report of the Royal Commission on National Museums and Galleries, Sir Joseph (later Lord) Duveen generously offered to build a new gallery for the Parthenon sculptures at his own expense. This offer was gratefully accepted by the Museum's Trustees, and on Duveen's recommendation the design of the new gallery was entrusted in 1930 to an American architect, John Russell Pope. After protracted discussion of the designs, construction of the new gallery began in 1936 and was completed in 1938. An opening ceremony was planned for the summer of 1939, but the sculptures were still being transferred to their new positions when the imminence of war and the likelihood of air-raids made it necessary to take steps for their protection. Initially they were kept in the gallery, protected by structures of corrugated iron with a timber

framework and an outer cover of sand-bags. Later the frieze was removed to the shelter of the London Underground, while the metopes and pedimental figures were kept in the Museum's vaults. This evacuation was timely, for in 1940 the Duveen Gallery was severely damaged by bombing.

When the time came to reinstate the exhibition of the Parthenon sculptures after the war, the Duveen Gallery was still unfit for use. Rather than revive the congested pre-war arrangement, it was decided not only to omit the plaster casts but to provide more space for the original sculptures.

84 The old arrangement of Parthenon sculptures in the Elgin Room. The original sculptures from the west pediment have been augmented by plaster casts of Athena's head and the front of Poseidon's torso.

85 The Duveen Gallery.

The metopes were, therefore, placed in a separate room, allowing the pedimental figures to be exhibited for the first time without other sculptures on the walls behind them, while the models and other illustrative material were shown in an anteroom. These rooms were opened in 1949.

In 1960 work at last began on the restoration of the bomb-damaged Duveen Gallery. The work was completed in 1961 and included a new ventilation system that incorporated an electrostatic precipitator to cleanse the air. When the marbles had been moved to their new places, the exhibition was opened in 1962. The frieze is exhibited in the large central gallery with the metopes and the pedimental figures in transepts at each end. Near the entrance are two smaller slip-rooms. The south slip-room (on the left of the entrance) contains an introductory exhibition about the Parthenon and the Elgin Collection. The north slip-room (opened in 1975) adds the architectural members from the Parthenon and those sculptures that are too fragmentary to be understood without the kind of detailed explanation, including drawings and photographs, that is thought inappropriate for the main exhibition.

Further Reading

Many books and articles have been written about the Parthenon and its sculptures. The following, most of which include detailed bibliographies, are particularly useful to those who read only English:

BERNARD ASHMOLE
Architect and Sculptor in Classical Greece
(London and New York 1972)

JOHN BOARDMAN
'The Parthenon Frieze – Another View', in *Festschrift für Frank Brommer*
(Mainz 1977)

FRANK BROMMER
The Sculptures of the Parthenon
(London 1979)

MARTIN ROBERTSON and ALISON FRANTZ
The Parthenon Frieze
(London 1975)

MARTIN ROBERTSON
A History of Greek Art
(Cambridge 1975)

WILLIAM ST CLAIR
Lord Elgin and the Marbles
(London and New York 2nd edn, 1983)

JOHN TRAVLOS
Pictorial Dictionary of Classical Athens
(London 1971)

Glossary

acroterion (plural, *acroteria*) Sculptured ornament especially at the apex or outer angle of a pediment.

aegis A breastplate of goatskin fringed with snakes, worn by Athena.

apobates (plural *apobatai*) A soldier armed with helmet, breastplate and shield, who demonstrated his skill and agility by leaping on and off a moving chariot.

arrephoros (plural *arrephoroi*) A young Athenian girl chosen to participate in the cult of Athena. The *Arrephoroi* lived on the Acropolis, helped to set up the loom for the weaving of the peplos and took part in other rituals.

athlothetes (plural *athlothetai*) Judge or steward at the games, especially the ten members of the organising committee for the Panathenaic festival.

caduceus (Latin equivalent of *kerykeion*) a herald's staff.

chiton A tunic, normally about knee-length for men, ankle-length for women and charioteers.

chlamys An outer cloak, fastening at the neck with a brooch, worn by men.

Eileithyiai The goddesses of childbirth (often used in the singular as a proper noun).

Eleusinian Mysteries A secret fertility cult in honour of Demeter and Persephone at Eleusis, some 22km west of Athens.

Eponymous Heroes Ten legendary heroes who gave their names to the ten tribes among which the Athenian citizens were divided under the constitution of Cleisthenes.

Hellenotamiai (literally 'treasurers of the Greeks') Athenian citizens who served as treasurers of the Delian League.

hydria (plural *hydriai*) A water-jar with three handles, two at the sides for lifting, one between lip and shoulder for pouring.

kantharos A drinking-cup with two vertical handles that usually project above the rim; often associated with Dionysos.

kerykeion A herald's staff, often used as a sign of office by Hermes, the messenger of the gods.

kithara a stringed instrument with a wooden sounding-box. (A lyre was similar, but had a tortoise shell for a sounding-box.)

metope A rectangular panel alternating with the triglyphs of the Doric frieze.

oinochoe (plural *oinochoai*) A wine-jug.

pediment A low triangular gable at each end of a pitched roof, e.g. on a Greek temple.

peplos An item of women's clothing consisting of a rectangle of material usually tied around the waist and secured at the shoulders with pins; in particular a robe presented to Athena at the Great Panathenaia.

petasos A wide-brimmed sun-hat, especially used by travellers and therefore appropriate to Hermes, the messenger of the gods.

phiale (plural, *phialai*) A shallow bowl for pouring libations, i.e. offerings of wine to the gods.

thymiaterion An incense-burner.

thyrsos A staff carried by Dionysos and his followers, consisting of a fennel stalk, wreathed with ivy.

triglyph An upright oblong with vertical grooving, alternating with the metopes of a Doric frieze.

Index

Photo Acknowledgements

The author and publishers are grateful to the following for permission to reproduce photographs:

The Earl of Elgin, 76
Lee Boltin, *front cover*, 82
Bibliothèque Nationale, Paris, 17, 36, 55
Royal Ontario Museum, 12

Figs 2, 3, 10 and 75 are the author's copyright. All other photographs have been provided by the Photographic Service of the British Museum.